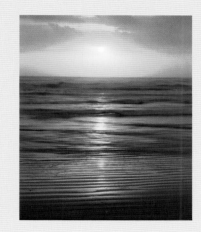

*Texas Coast*

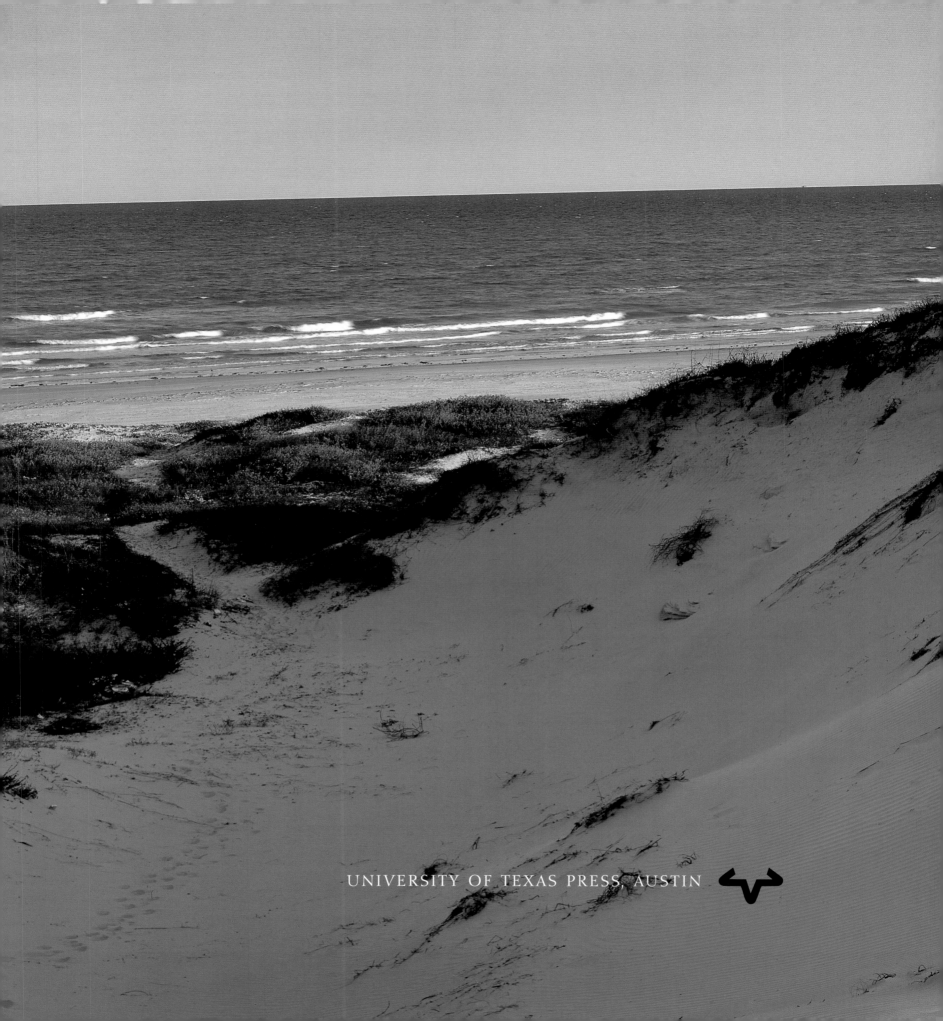

UNIVERSITY OF TEXAS PRESS, AUSTIN

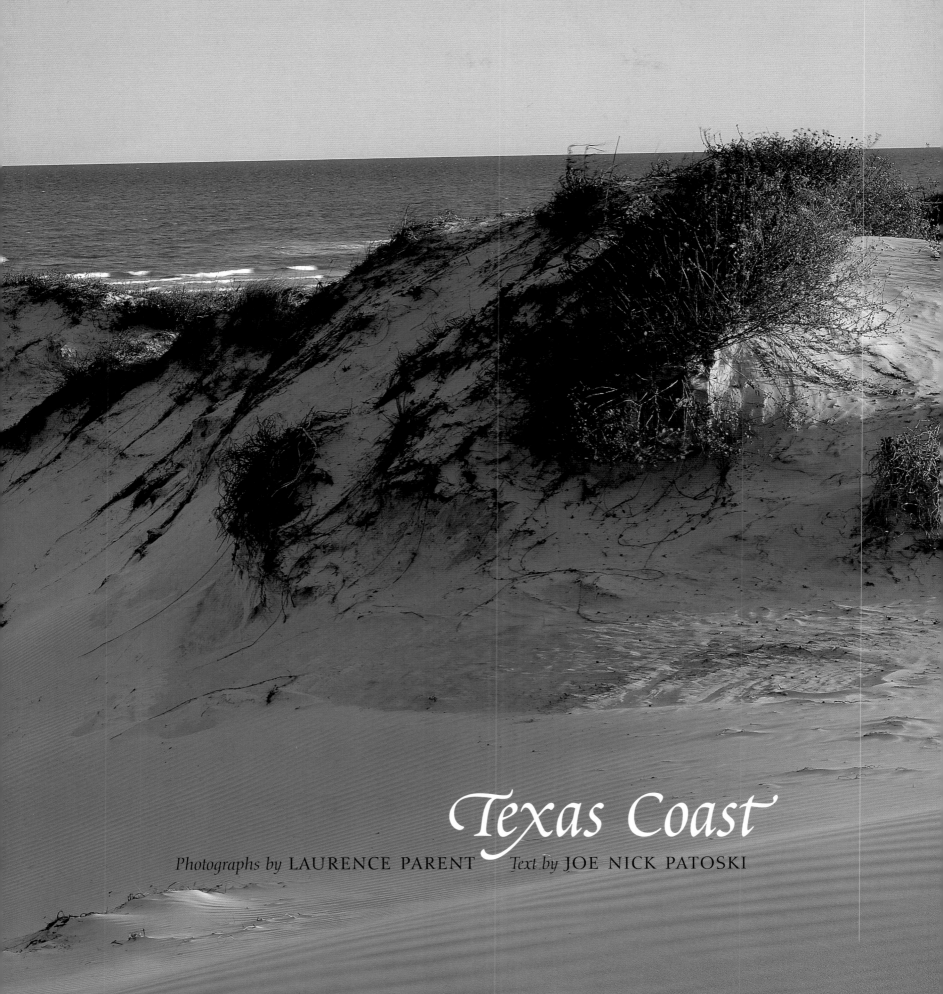

# Texas Coast

Photographs by LAURENCE PARENT    Text by JOE NICK PATOSKI

*The publication of this book was made possible*
*by a gift made in honor of Edward Randall III by Ellen B. Randall*
*and by a gift from Charles Butt.*

BOOK DESIGN AND TYPESETTING: TERESA W. WINGFIELD

LIBRARY OF CONGRESS CATALOGING-IN-PUBLICATION DATA
Parent, Laurence.
  Texas coast / photographs by Laurence Parent ; text
by Joe Nick Patoski.—1st ed.
    p.    cm.
  ISBN 0-292-70299-x (cloth : alk. paper)
  1. Gulf Coast (Tex.)—Pictorial works.  2. Gulf Coast
(Tex.)—Description and travel.  3. Gulf Coast (Tex.)—
History, Local.  4. Natural history—Texas—Gulf Coast.
5. Texas—Pictorial works.  6. Texas—Description and
travel.  7. Texas—History, Local.  8. Natural history—
Texas.  I. Patoski, Joe Nick, 1951–  II. Title.
F392.G9P37  2005
976.4–dc22                    2005009167

PAGE 1: *Sunrise, Padre Island National Seashore*
PRECEDING PAGES: *Padre Island National Seashore*

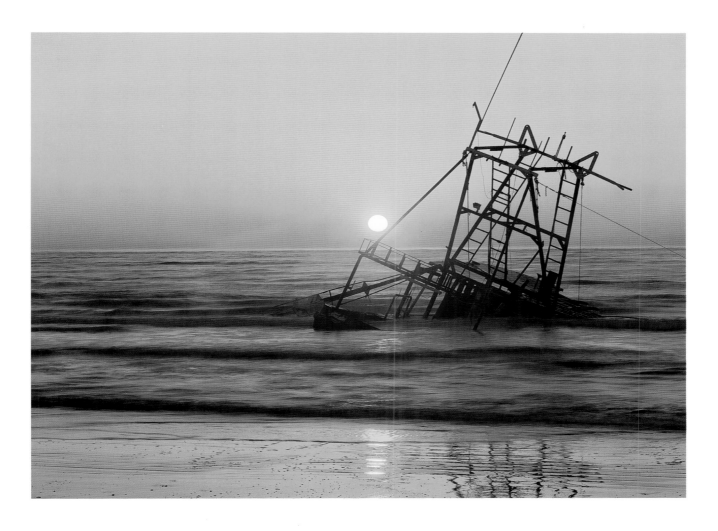

*Shipwreck, Bryan Beach*

**Texas Coast**

PORT ARTHUR ●
SABINE LAKE

HOUSTON ●

SAN JACINTO BATTLEGROUND ●

● ANAHUAC WILDLIFE REFUGE

BOLIVAR PENINSULA
TEXAS CITY ●
● PORT BOLIVAR
● GALVESTON
GALVESTON ISLAND

VARNER–HOGG PLANTATION ●

FREEPORT ● SURFSIDE BEACH
BRYAN BEACH

SAN BERNARD NATIONAL WILDLIFE REFUGE ●

PALACIOS ●

MATAGORDA PENINSULA

● PORT LAVACA

ARANSAS NATIONAL WILDLIFE REFUGE ●
MATAGORDA ISLAND

● GOOSE ISLAND
FULTON MANSION ●

● ARANSAS PASS
CORPUS CHRISTI ●
CORPUS CHRISTI BAY
MUSTANG ISLAND

PADRE ISLAND

PADRE ISLAND NATIONAL SEASHORE

PORT MANSFIELD ●

LAGUNA ATASCOSA ●
NATIONAL WILDLIFE REFUGE

SOUTH PADRE ISLAND

LAGUNA MADRE

● PORT ISABEL
● BOCA CHICA
● BROWNSVILLE

N

*This book is dedicated to my wife,*
*Patricia Caperton Parent, a true child of*
*the Texas Coast.* —L.P.

*To my parents and all the other salts who've*
*shown me the beauty of this magnificent*
*shoreline, to my wife, Kristine, and to my*
*kids, who have vividly demonstrated that*
*when it comes to the coast, the joys of my*
*childhood are their joys, too.* —J.N.P.

*Aransas Pass Lighthouse, Port Aransas*

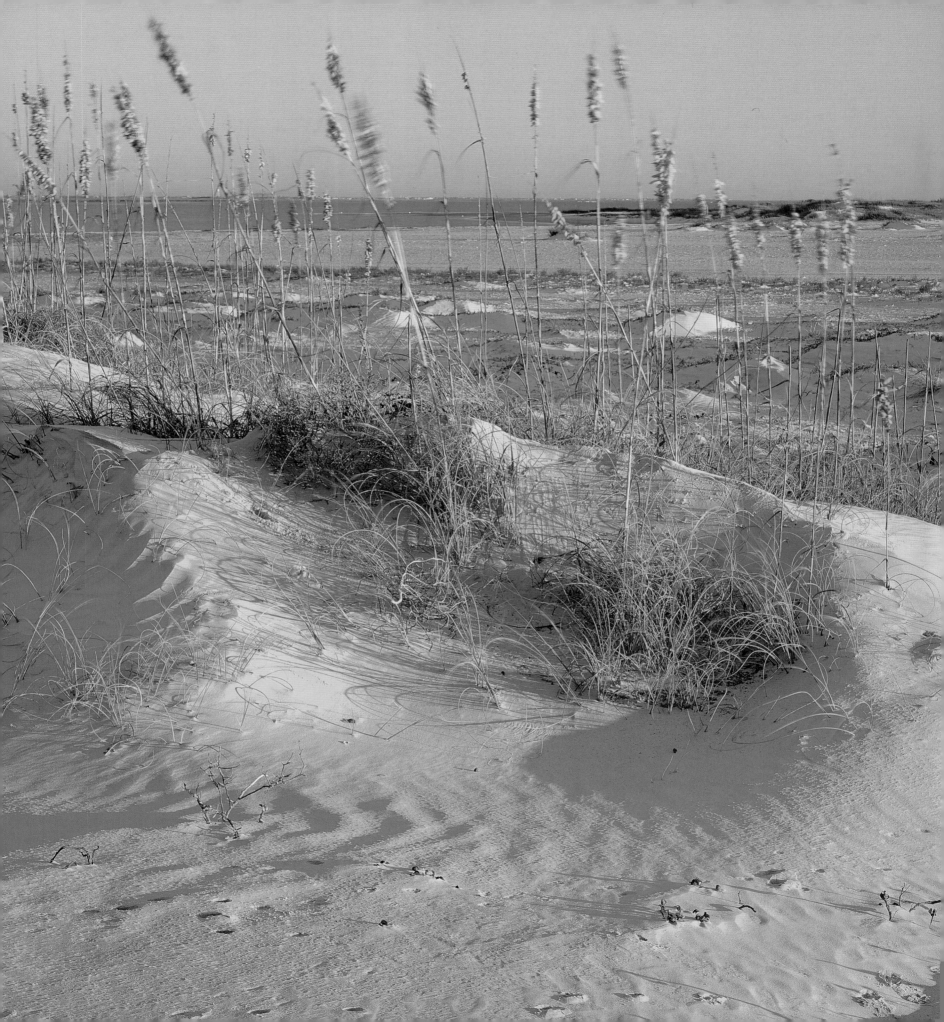

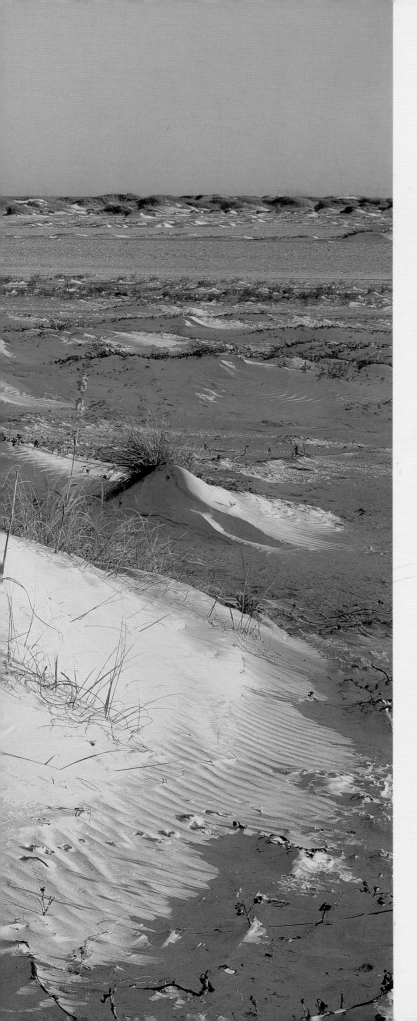

*T*he long, languid coastline of Texas takes her own sweet time seducing the senses. Lacking the immediate drama of an initial encounter with California's Big Sur, where the Pacific crashes against craggy cliffs and rugged outcroppings, or the soothing tropical ambience of the Florida Keys, she is not a stunner at first sight. But give her time, and that fine line where Texas meets the sea will steal your heart.

The Texas coast is the essence of the shore: sun, sand, surf, dunes, flats, wetlands, bays, estuaries, islands, and peninsulas. On the whole, it is a complex soup rich in marine life, shorebirds, and waterfowl. Industry is abundant along the same coastline for different reasons, mainly the easy access to the Gulf and the world beyond. Many of the more scenic parts of the coast have been obscured by resorts, condos, homes, and businesses. But even with those distractions and diversions, the Texas coast, that precise point at which sand, sky, and water converge, nourishes the soul like no other physical place on Earth.

*The Texas coast emerges* out of the murky swamps of southwest Louisiana at Sabine Pass and makes a near perfect crescent for 377 miles all the way to the desiccated flats of Boca Chica, where the

*Dunes and sea oats, Matagorda Island*
*State Park and National Wildlife Refuge*

9

Rio Grande enters the Gulf of Mexico. Along that path, the story of a state, its people, and the natural world surrounding them unfolds.

*The Gulf of Mexico* is the most American of all waters, encompassing 596,000 square miles. It is the ninth-largest body of water in the world. Five states including Texas, five states in Mexico, and the island nation of Cuba share its waters, utilizing it as a source of sustenance and a means of getting around.

The Gulf is the primary supplier of water vapor that brings rain to the central and eastern United States. It produces a quarter of the United States' commercial fish and shrimp catch. Nine-tenths of the country's offshore oil and gas production comes from the Gulf. In return, it receives sediment and pollution from two-thirds of the United States, mostly from the Mississippi River.

The Texas coast plays a critical role in this productivity. Most migrating birds traveling the eastern and midwestern flyways leave and reenter the country via the Texas coast. Seventy-five percent of the migratory fowl in the United States depend on the wetlands of the Texas coast. So do the nation's automobiles and trucks—two-thirds of the country's petrochemical refineries are located near the Texas coastline.

Seven major bays, some as much as thirty-five miles in length or breadth, define the landmass behind the beaches along the Texas coast. Except during storm events, the Gulf's waves are relatively insignificant, though constant enough to work like a washboard to form three sets of sandbars off the shore.

*The actual beginning* of the Texas coast is an ill-defined spit of salt marsh called Texas Point, on the west side of Sabine Pass, where the Sabine River, separating Texas from Louisiana, meets the Gulf. Land's end is most easily reached by boat. A small two-lane bridge spans the river several miles above the pass, linking Louisiana Highway 82 to downtown Port Arthur, where it intersects Texas Highway 87. Highway 87 cuts through a major refinery zone before reaching open land and the town of Sabine Pass. Dowling Road and Jetty Road lead past a collection of rock pilings and mud flats to the pass proper, where the old lighthouse on the Louisiana side is the most prominent landmark.

*Aransas Bay tidal flats, Goose Island State Park*

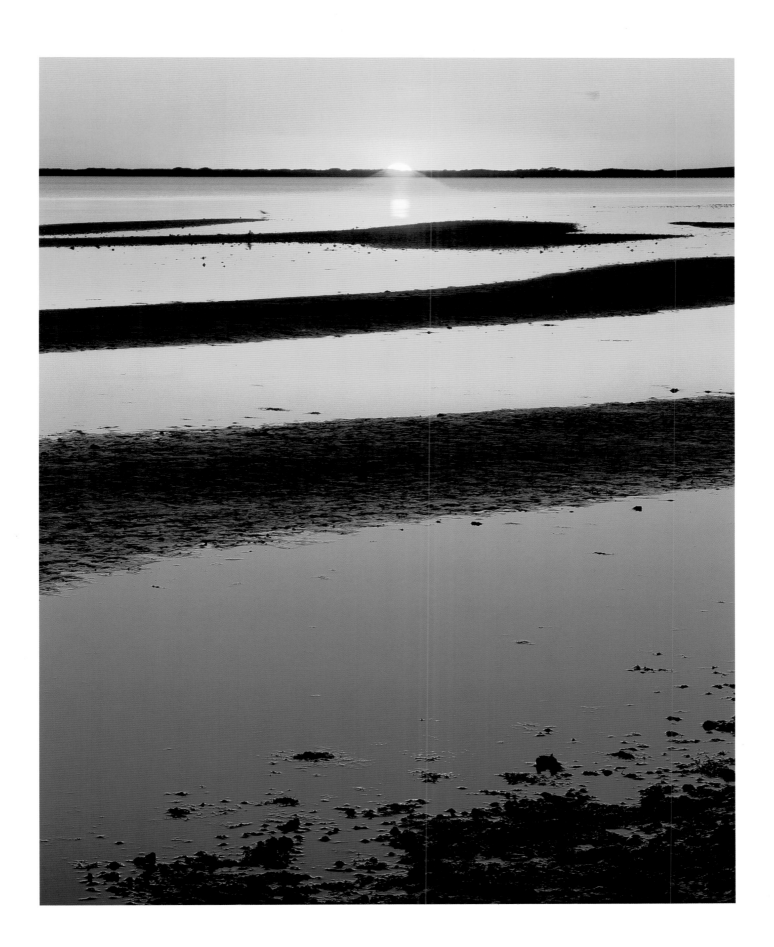

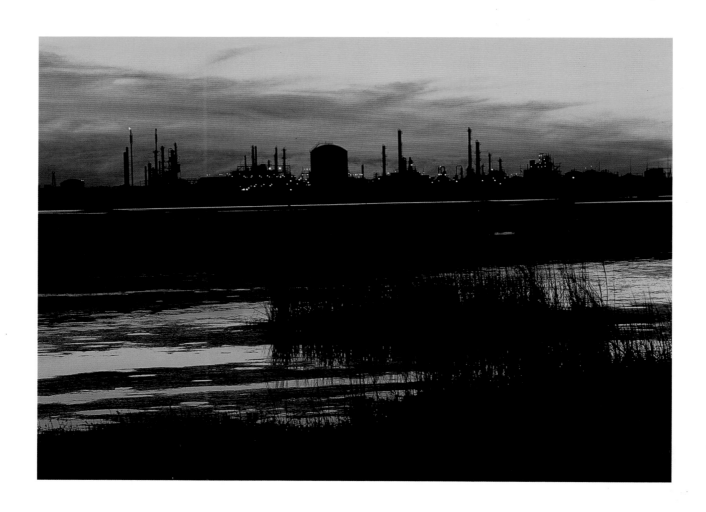

*Petrochemical plants, Freeport*

Sabine Pass Battleground State Park, upriver, is where Lieutenant Dick Dowling and a band of forty-six tough Irish dockhands from Galveston on behalf of the Confederacy used six cannons to destroy four Union gunboats in a notorious Civil War battle back in 1863. Sabine Pass was initially envisioned as a major port, but its exposure to hurricanes ultimately made Port Arthur (farther inland) the port of preference. The town of Sabine Pass later became famous for a messy culinary specialty called barbecued crab. (Blue crab is one of the delicacies of the Texas coast, exported to restaurants around Chesapeake Bay when the local fare there is out of season.)

*The upper Texas coast* goes underappreciated, in no small part because of its steadily eroding shoreline. Highway 87, which once hugged the beach from Sabine Pass to the Port Bolivar (pronounced BALL-iver) Lighthouse and the Galveston ferry, no longer exists along a twenty-mile stretch. High Island, where the road resumes, marks the beginning of the Bolivar Peninsula, a slim sandbar twenty-seven miles long and no more than three miles wide, the first in a succession of offshore barrier islands that define the coast. The communities of High Island, Port Bolivar, Crystal Beach, Gilchrist, and Caplen aren't real towns so much as scattered clusters of beach homes and fishing businesses. Bolivar is renowned for its fishing, crabbing, hunting, and, increasingly, its birding. High Island is directly across the Gulf from the Yucatán Peninsula, which explains its world-class reputation for observing the spring and fall migrations. The biggest landowner on the peninsula is the Houston Audubon Society.

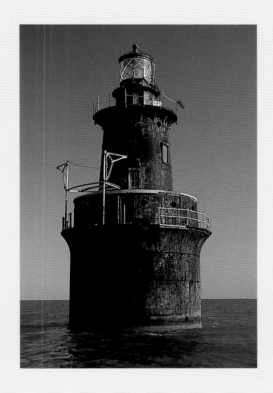

Sabine Bank Lighthouse
(Eighteen-Mile Lighthouse)

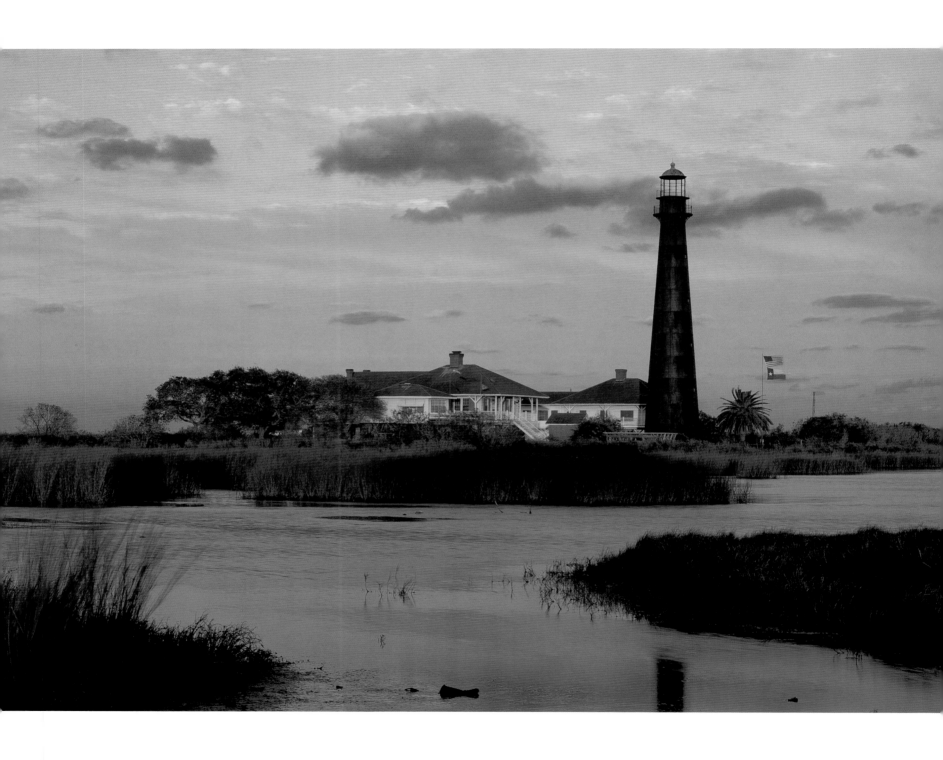

*Bolivar Point Lighthouse*

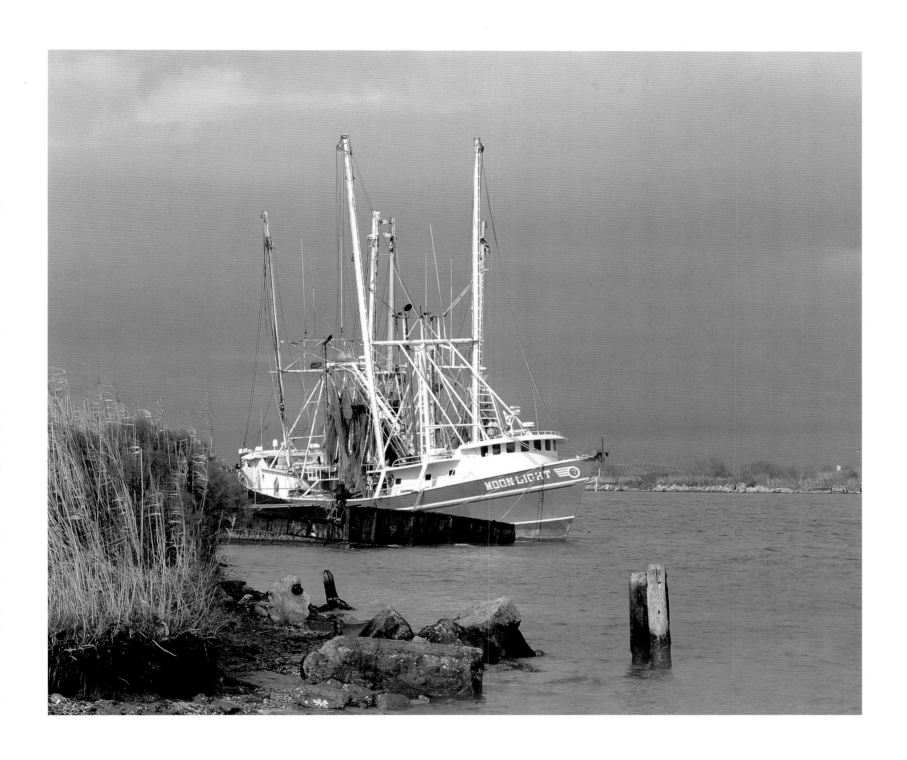

*Shrimp boat on Sabine River between Sabine Pass and Port Arthur*

Bolivar's illustrious past is not evident. Karankawa and Orcoquisa lived on the peninsula as far back as 10,000 years ago, and it served as the gateway to Galveston Island for tribes from East Texas. Cabeza de Vaca, the Spanish explorer who provided the first written descriptions of Texas, walked around Bolivar after washing ashore on Galveston Island in November of 1528. Rebels waging a private war against Spanish rule and pirates used Bolivar as a base of operations. The French-Creole pirate Jean Lafitte, who headquartered in Galveston after fighting on behalf of the United States in the 1815 Battle of New Orleans, used the peninsula to move African slave traffic via slave runners, including Jim Bowie, from Galveston to the Sabine River, where Louisiana sugar planters paid one dollar a pound for human cargo. Cotton, cattle, oysters, and watermelon have been mainstays of the peninsula's economy at one time or another. The salt dome of High Island and other nearby domes store the bulk of the United States' strategic oil reserves.

The Port Bolivar Ferry to the island is the longest ferry ride in Texas linking public roadways. It takes eighteen minutes to travel 2.7 miles across the maw of busy Galveston Bay. It's the best free ride in the state, passing Civil War bunkers and the black cast-iron Bolivar lighthouse, a parade of shipping traffic, and Sea Wolf Park.

*Port Bolivar Ferry, Galveston*

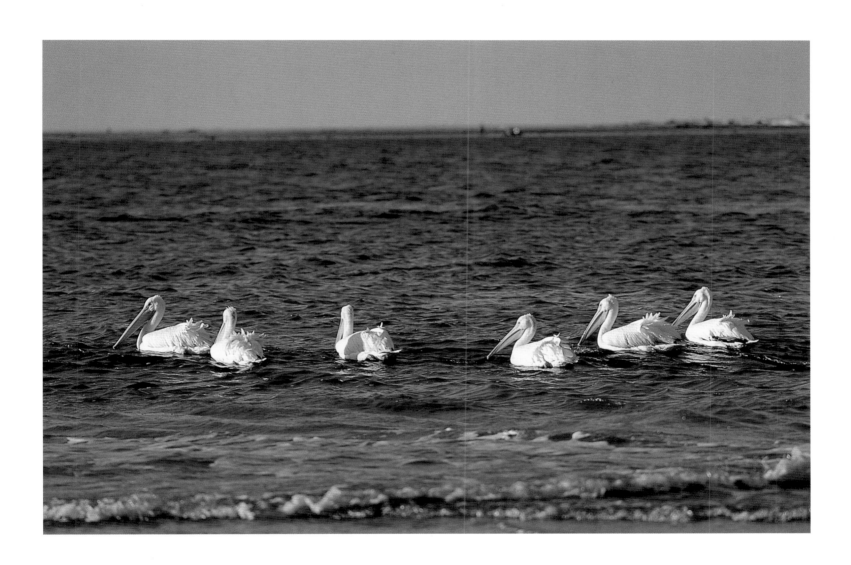

*Pelicans, Bryan Beach*

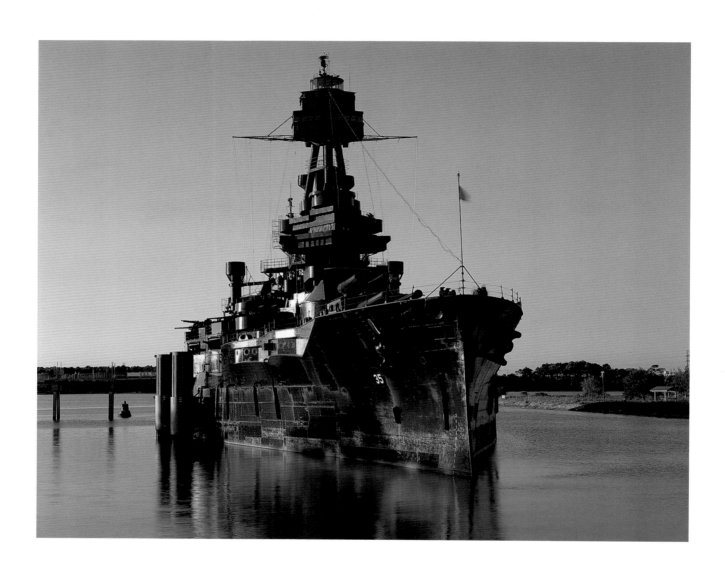

*Battleship Texas and Houston Ship Channel,*
*San Jacinto Battleground State Historic Park*

*San Jacinto Monument and pool,*
*San Jacinto Battleground State Historic Park*

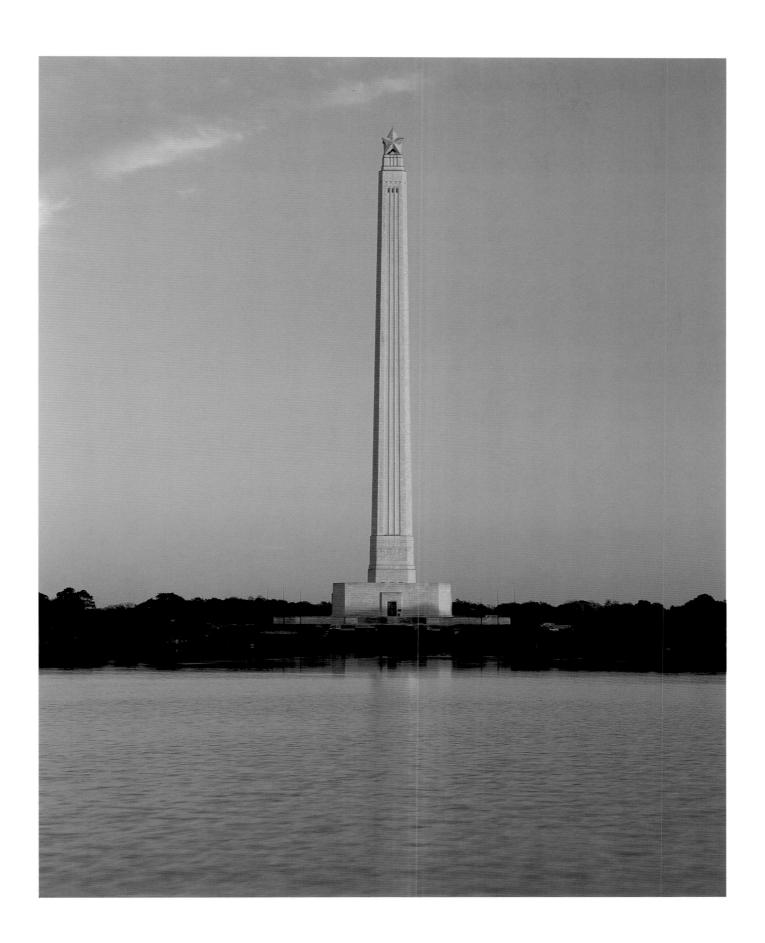

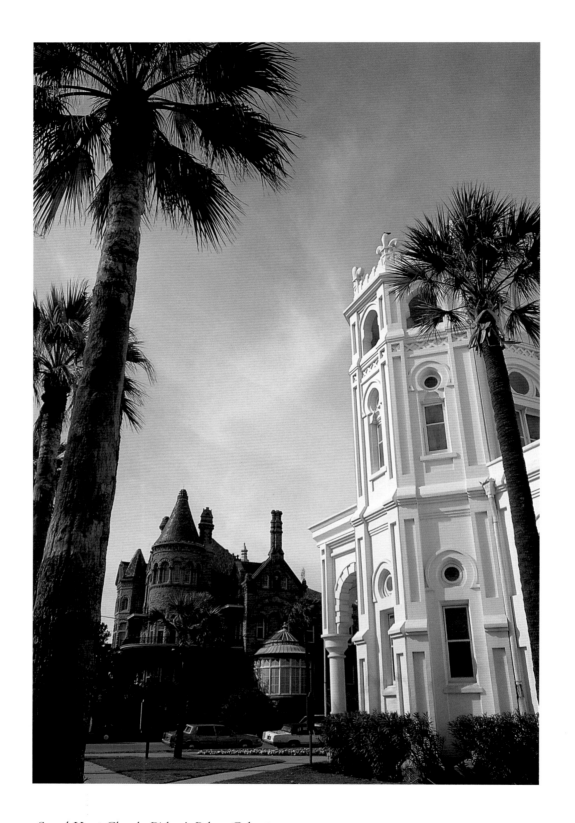

*Sacred Heart Church, Bishop's Palace, Galveston*

*In Galveston,* you're somebody if you're BOI—Born on the Island—especially if you're a Moody or a Kempner. Galveston is old Texas, and those families are old Galveston money.

Galveston used to be the state's biggest port until the Houston Ship Channel became a deepwater port in 1919. The city was once upon a time synonymous with high times and high rolling until May 30, 1957, when new sheriff Paul Hopkins raided the Balinese Room, a storied nightclub on stilts that extended several hundred feet into the Gulf, where illegal gambling was a long-tolerated tradition. The gift shop and museum that now occupy the space capitalize on those faded memories.

This is a real port town, the most urban beach resort in Texas, and a cloudy dream version of a New Orleans that hardly exists even in New Orleans anymore. Cruise down Broadway under the elderly palms, by the streetcar line flanked by elegant mansions, and you could just as well be on St. Charles Avenue. Galveston is where cutting-edge research is conducted on biological terrorism at a University of Texas lab and where marine science is studied at Texas A&M facilities.

Galveston bore the brunt of the Great Storm of 1900, a stealth hurricane that drowned the island and killed six thousand people, more than any other disaster in Texas history. Galveston is the Seawall,

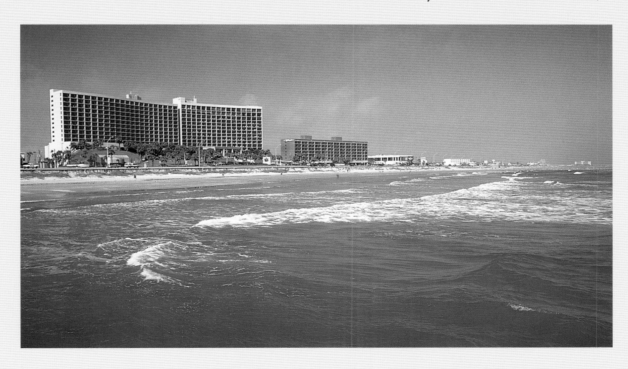

*Galveston Beach*

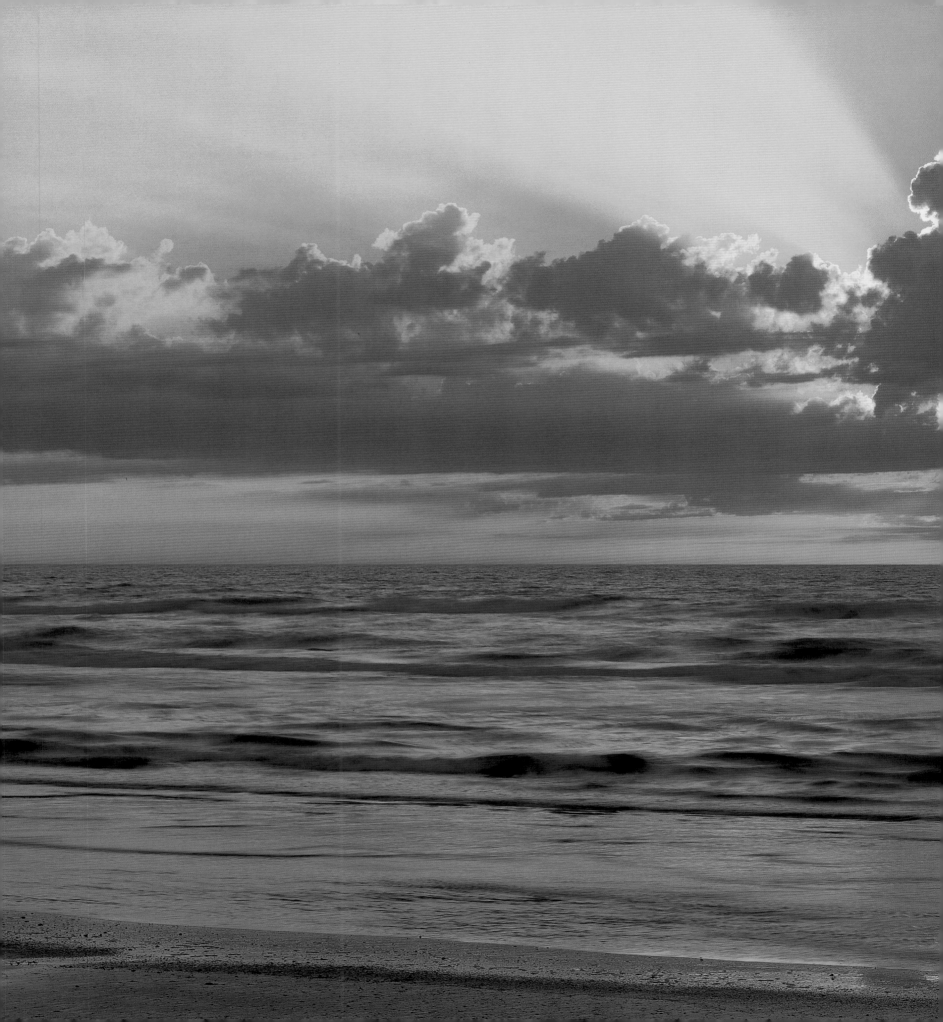

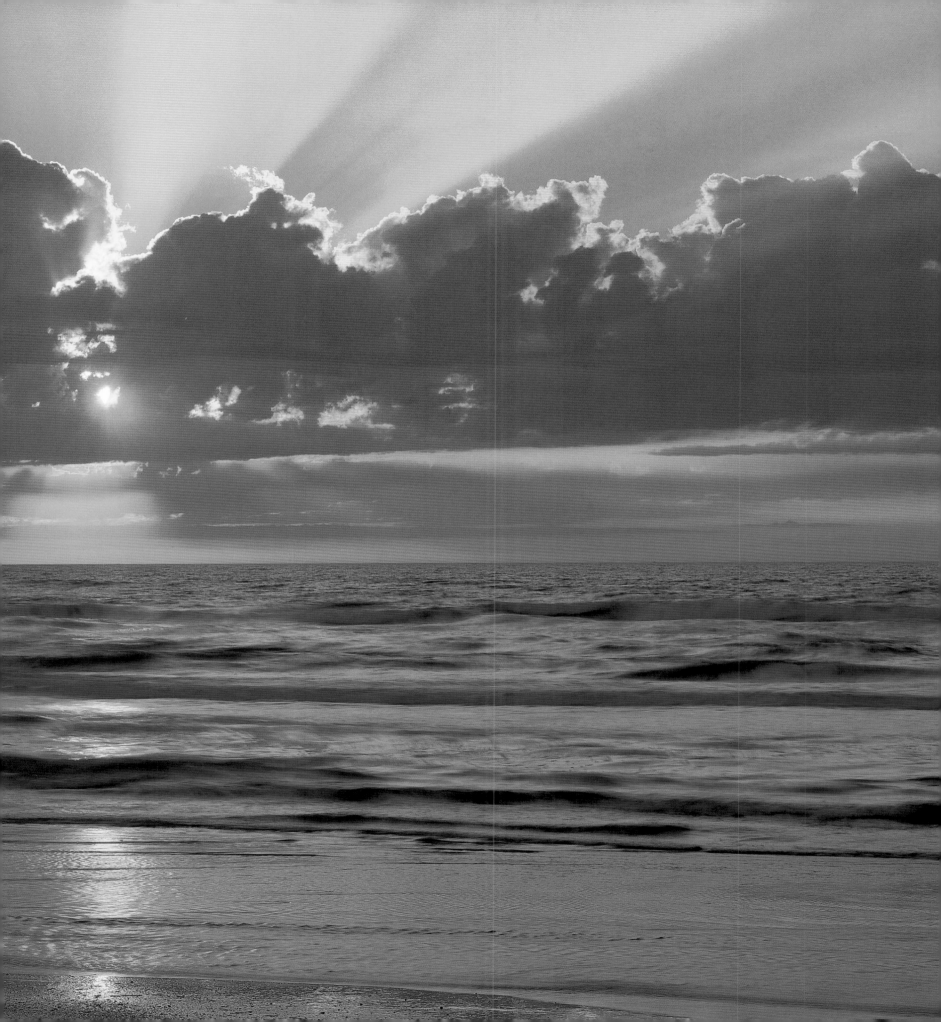

the location of the original spring break, Alpha weekend, Stewart Beach, the tall ship *Elissa* and the Texas Seaport Museum, and the Flagship Pier. Galveston is the biggest Mardi Gras this side of the Crescent City and the Moody Gardens rainforest-under-glass, IMAX included.

Enough remnants of the past survive to qualify the city as Texas's most historic, though San Antonians might quibble with that brag. The Hotel Galvez is still a grande dame. The Strand, several city blocks of sturdy red-brick and cast-iron structures, has been gussied up and now bustles more than it has since it was the Wall Street of the South back at the close of the nineteenth century. But there's still just enough funk between the city's toes, such as the Poop Deck, "Where the Elite Meet in Their Bare Feet," and the stepped-up rice and turnip greens at Leon's World's Finest In and Out B-B-Q House, to keep the place honest, just as jalousies of the weathered French provincial homes on the back streets keep the Bishop's Palace, perhaps the most majestic edifice in Texas, and the ancient Rosenberg Library in perspective.

*Recently constructed homes* in the style of those on Cape Cod and Cape Hatteras, many costing in excess of a million dollars, define progress on Galveston's West End. Open country beckons beyond the county and state parks, where the coastal prairie lights up on both sides of the Bluewater Highway in the spring with fields splashed by reddish-purple and yellow Indian blankets, red, orange, and yellow Indian paintbrushes, delicate pink evening primroses, fire-red and yellow Mexican hats, and brilliant yellow composites, while cattle graze in the distance. It's lonely enough for a young woman in a two-piece swimsuit to pull her white convertible onto the beach behind the dunes and work on her tan while reading a book without being bothered. A small one-man toll bridge distinguishes San Luis Pass—the largest natural pass on the Texas coast, marking the end of Galveston Island, the mouth of West Galveston Bay, and the beginning of San Luis and Follets islands. Cars parked along the shore signal the presence of fishermen patiently standing in the shallow water of the channel, waiting with poles in hand for something to catch.

*The Strand, Galveston*

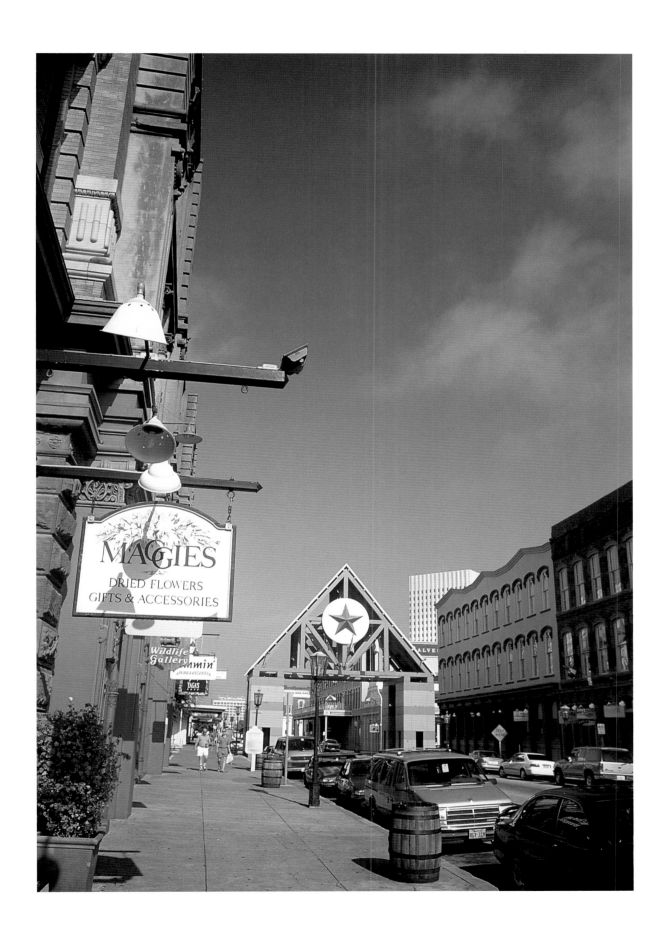

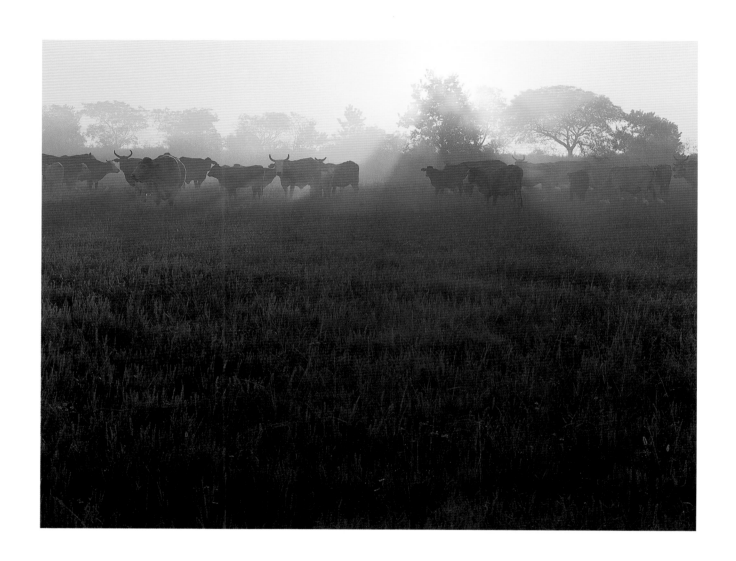

*Cattle and pasture on Gulf Coast, Brazoria County*

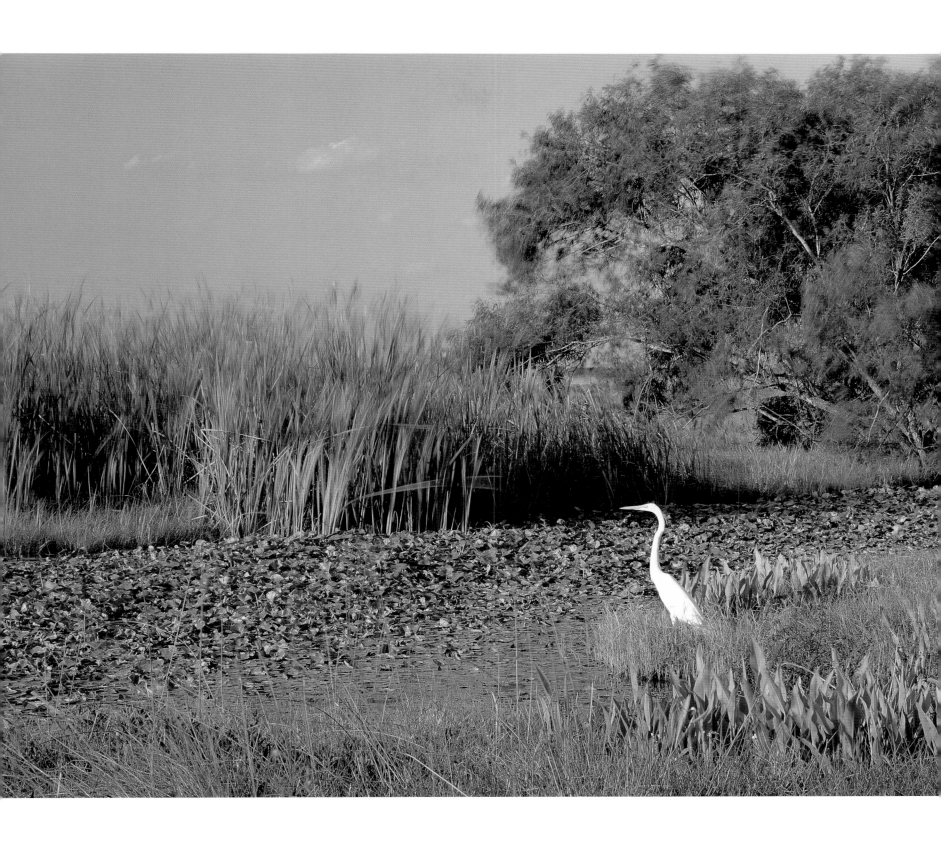

*Marsh and egret, San Bernard National Wildlife Refuge*

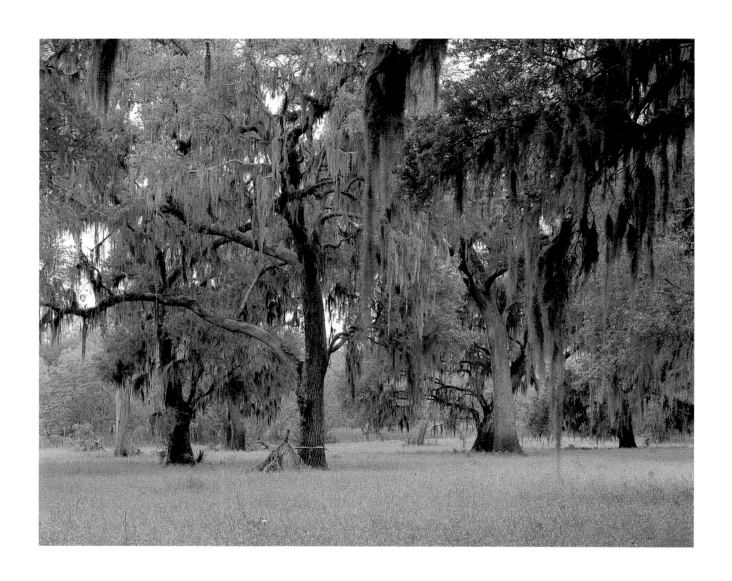

*Live oaks and Spanish moss, Brazos Bend State Park*                    *Varner-Hogg Plantation home and magnolia trees*

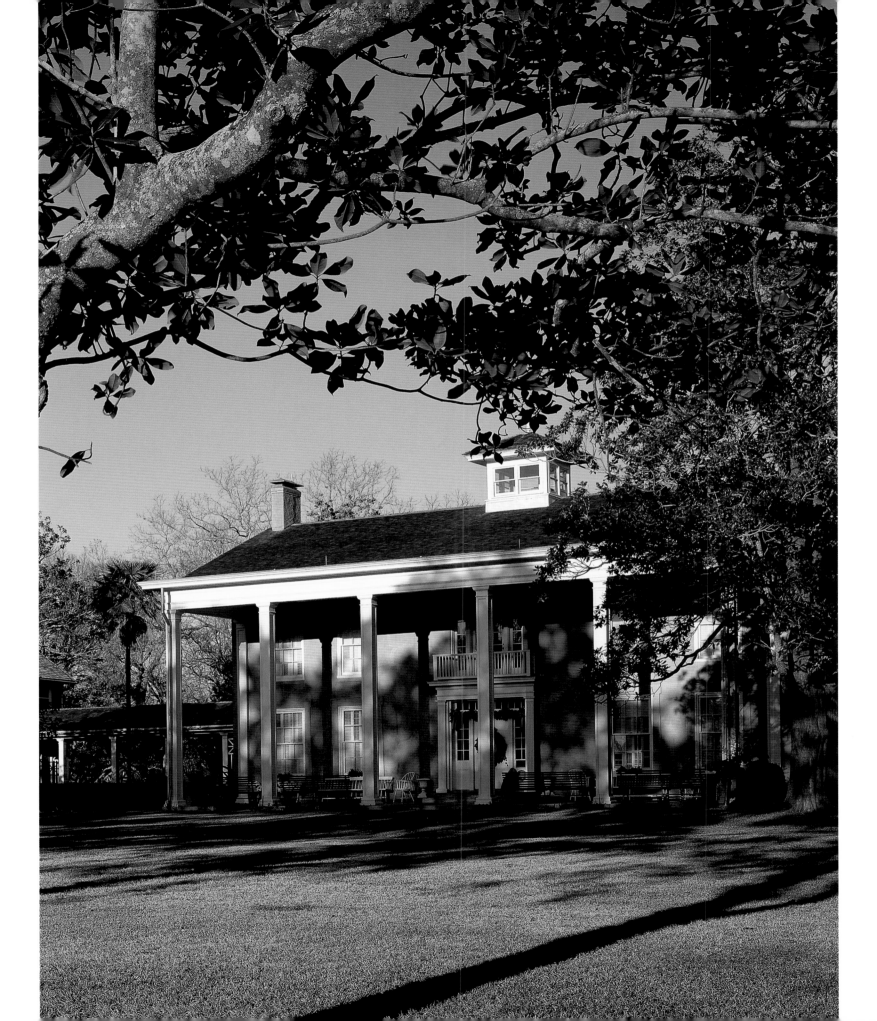

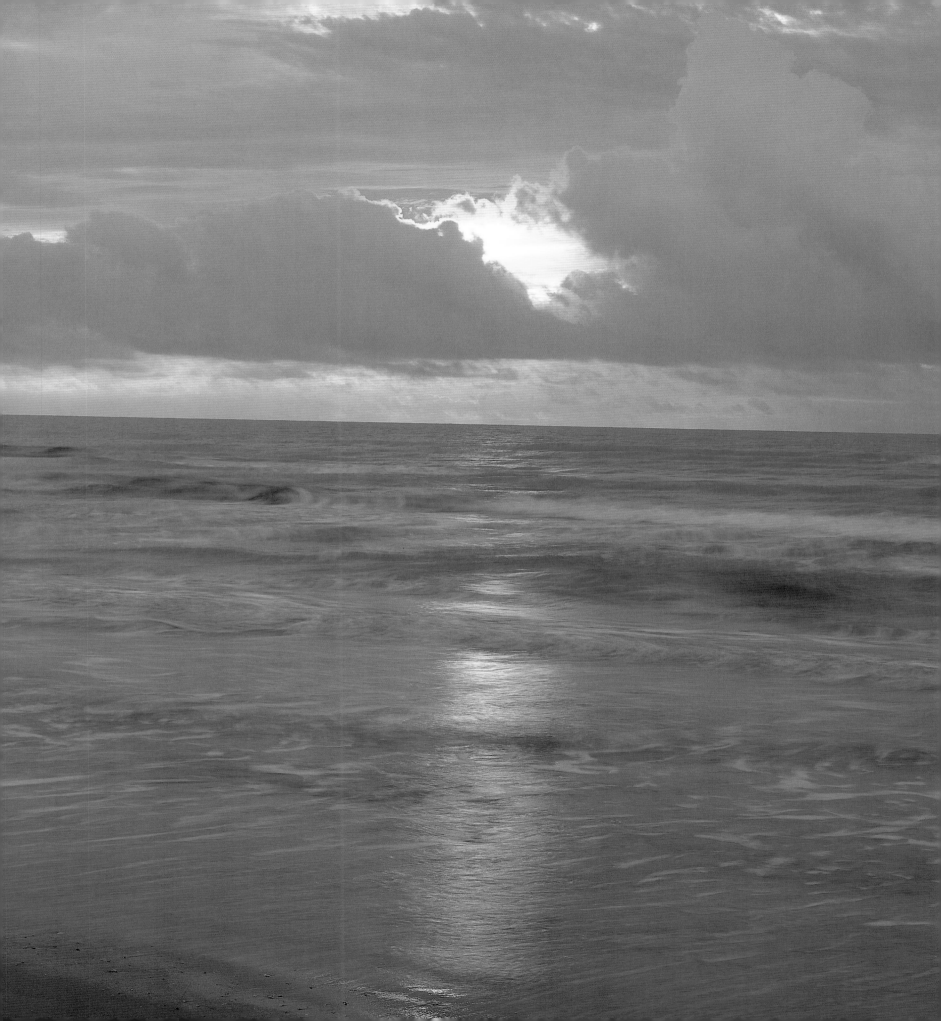

*The community of Surfside* is Galveston's opposite, neither old nor historic nor particularly upscale. Most of the unimposing collection of beach homes wouldn't survive a direct hit from a hurricane—it's a sensible way to live on the Texas coast.

*The town of Freeport* is no luxury resort either. Shipping and refining justify its existence. But Freeport is also the gateway to Flower Garden Banks National Marine Sanctuary, which contains the northernmost coral reef in the Gulf or the Caribbean, a mere 110 miles offshore. Throughout the year, dive boats run two- to three-day charter trips to the gin-clear water, where scuba divers can view more than 200 species of fish, 250 species of invertebrates, and 21 species of coral. Sharks, rays, and barracudas are abundant. Every dive boat is filled to capacity for the annual coral spawn, which occurs the night after the full moon in August, a quirk of nature in which the coral explodes, releasing millions of BB-size eggs.

*A September morning* dawns quiet and muggy after a full-moon night. Caney Creek is placid and still, calm as can be. No one is stirring in the fishing shacks on stilts that front the creek. The piers extending out from each shack are empty.

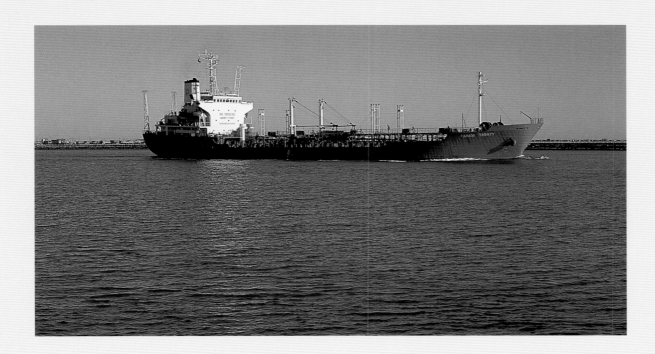

*Tanker, Freeport*

*Surfside Beach*

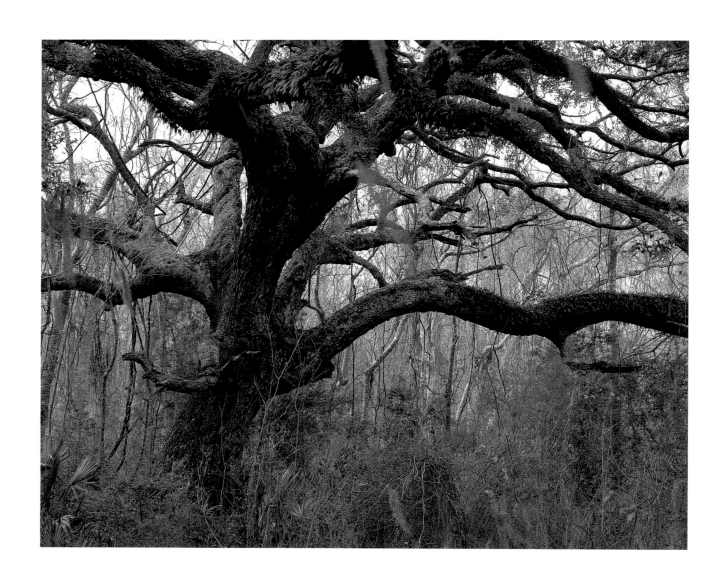

*Large live oak tree, Brazos River bottomlands, Lake Jackson*

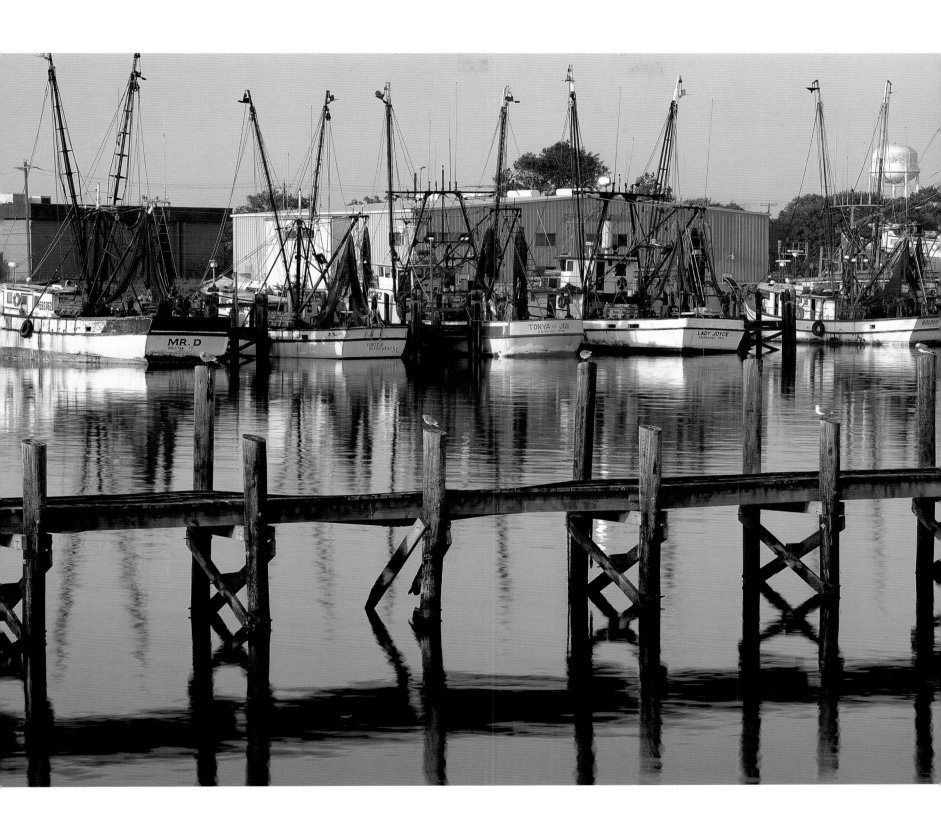

*Shrimp boats in Freeport harbor*

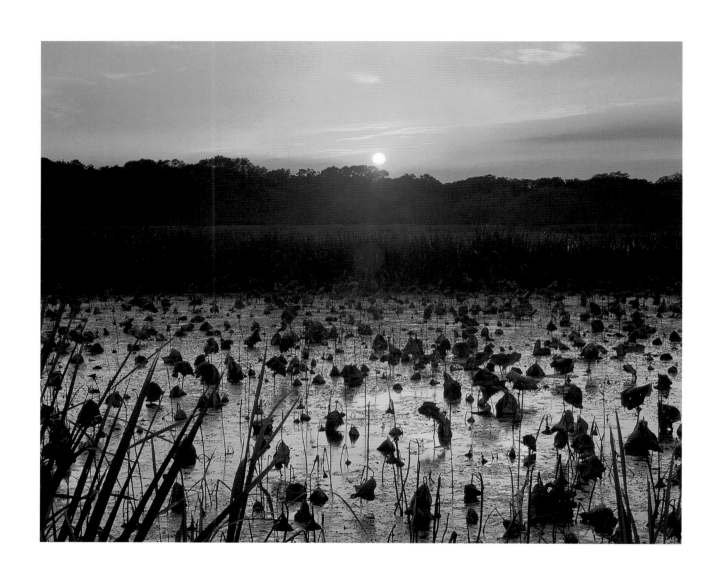

*Forty-Acre Lake, Brazos Bend State Park*

*Driftwood, Bryan Beach*

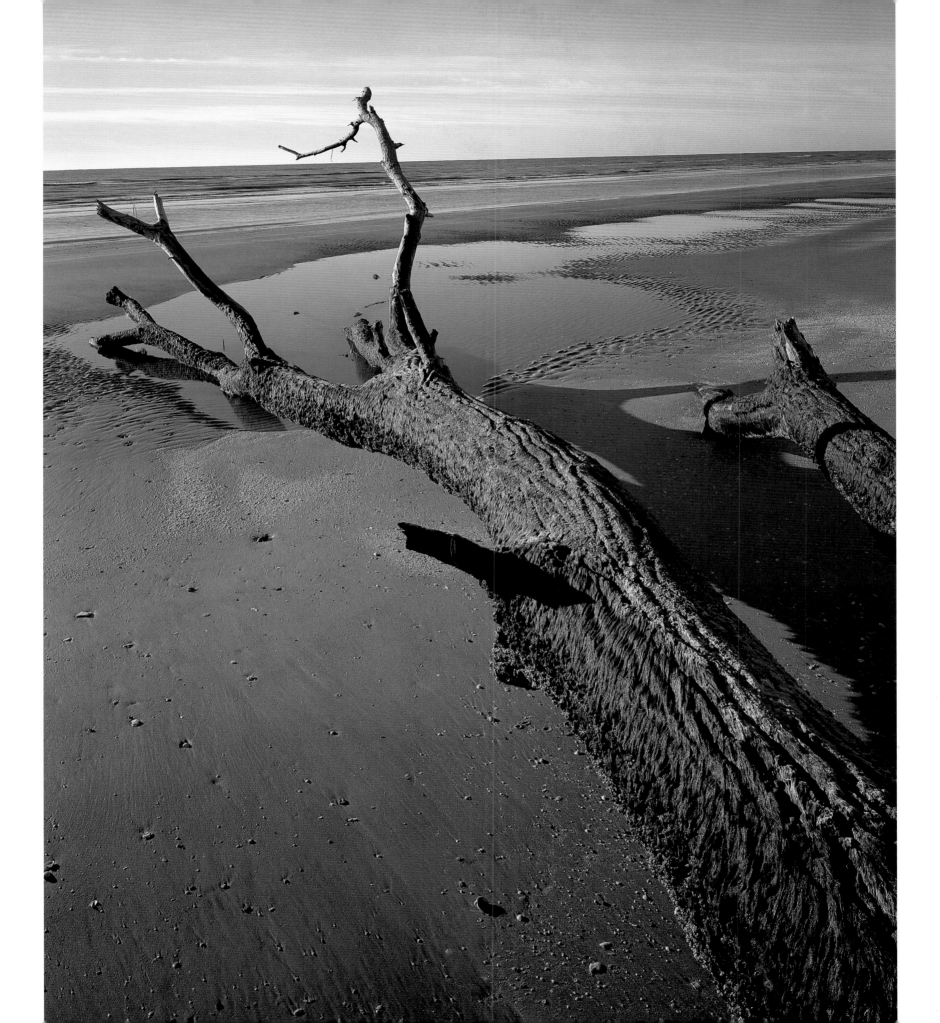

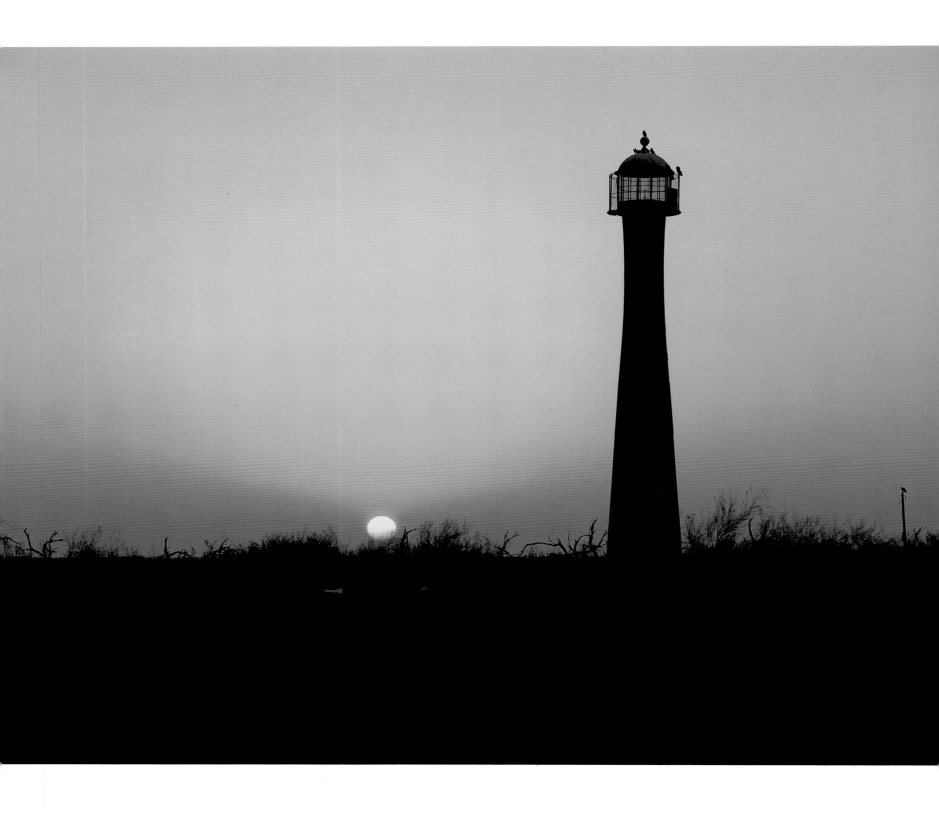

*Matagorda Lighthouse, Matagorda Island*

A fishing boat putters by every five minutes or so, headed for Matagorda Bay or the Gulf.

Tugs pushing barges in the distance seem to plow through the marsh grass, magically levitating on land. Thickets of tall green grass obscure the cleared path of the Intracoastal Waterway canal nearby.

The Intracoastal, also known as the Gulf Intracoastal Waterway, is an inland ditch 12 feet deep and 125 feet wide, stretching from Brownsville to Florida. The first navigable portion, the Galveston and Brazos Canal, was completed in 1853. The entire Texas stretch was finished in 1949. As appealing as the concept of a water highway may be, the constant dredging required to keep the channel open costs money and destroys sea grass, one of the basic building blocks of the marine nursery.

To the south and to the north thunderheads tower overhead, soaring to startling heights above the flat wetlands and defining a sky as expansive as that in far West Texas. Lower clouds scud in from the beach, riding the southeasterly sea breeze, demonstrating how quickly the weather changes on the coast in the seesaw battle between southerly and northerly winds.

On this morning, the creek, the bay, the estuaries, the whole arching Gulf coast from tip to toe belong to the wildlife. Seagulls squawking, mullet jumping out of the water with audible plops, pelicans flying in squadron formation scanning the water for breakfast, swirls of shorebirds spiraling in the distance in one organic mass as dense as the swarms of mosquitoes descending on any warm-blooded being that steps outside.

*The coast is nature* at her best and worst, dominating all, no matter how much humans try to tame her. Rot, wind, heat, mold fed by air that's thick and heavy with sea salt take their toll. Rust never sleeps on the Texas coast—the undersides of cars and trucks do not lie. Intense tropical downpours, blistering, steamy heat so intense that the horizon literally vibrates and roads and beaches shimmer with mirages, and numbing blue northers are givens. Hurricanes, rare perhaps but inevitable anytime from June to November, lurk in the background.

In certain cloudy conditions, the divisions between land, water, and sky become so abstract and ill-defined that the eye has a difficult time figuring where one ends and the other begins.

*Historic Luther Hotel, Palacios*

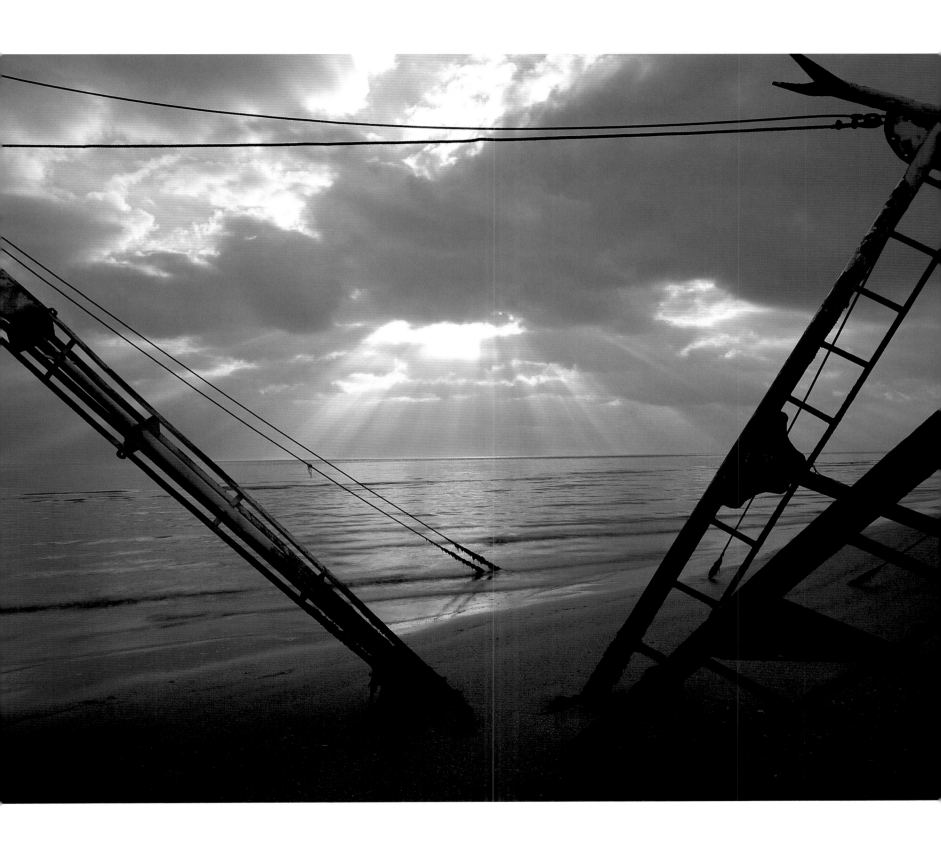

*Shipwreck on beach, Matagorda Island*

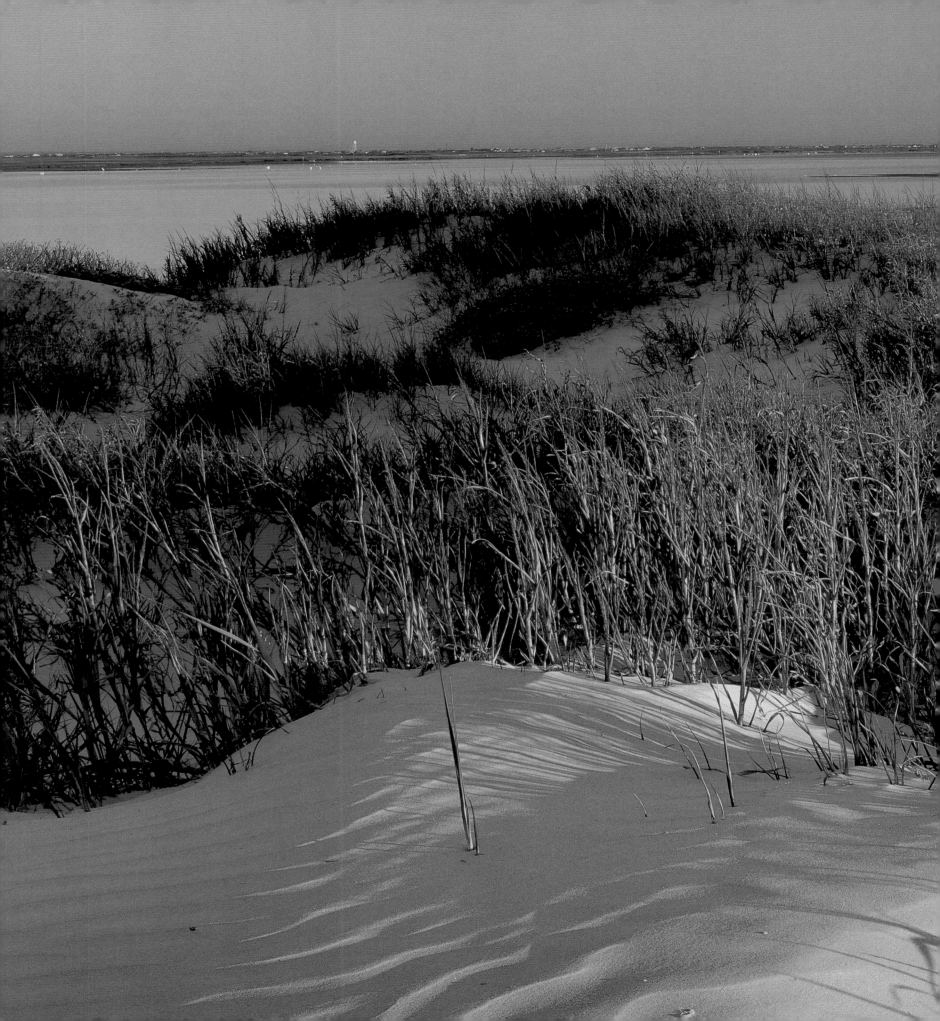

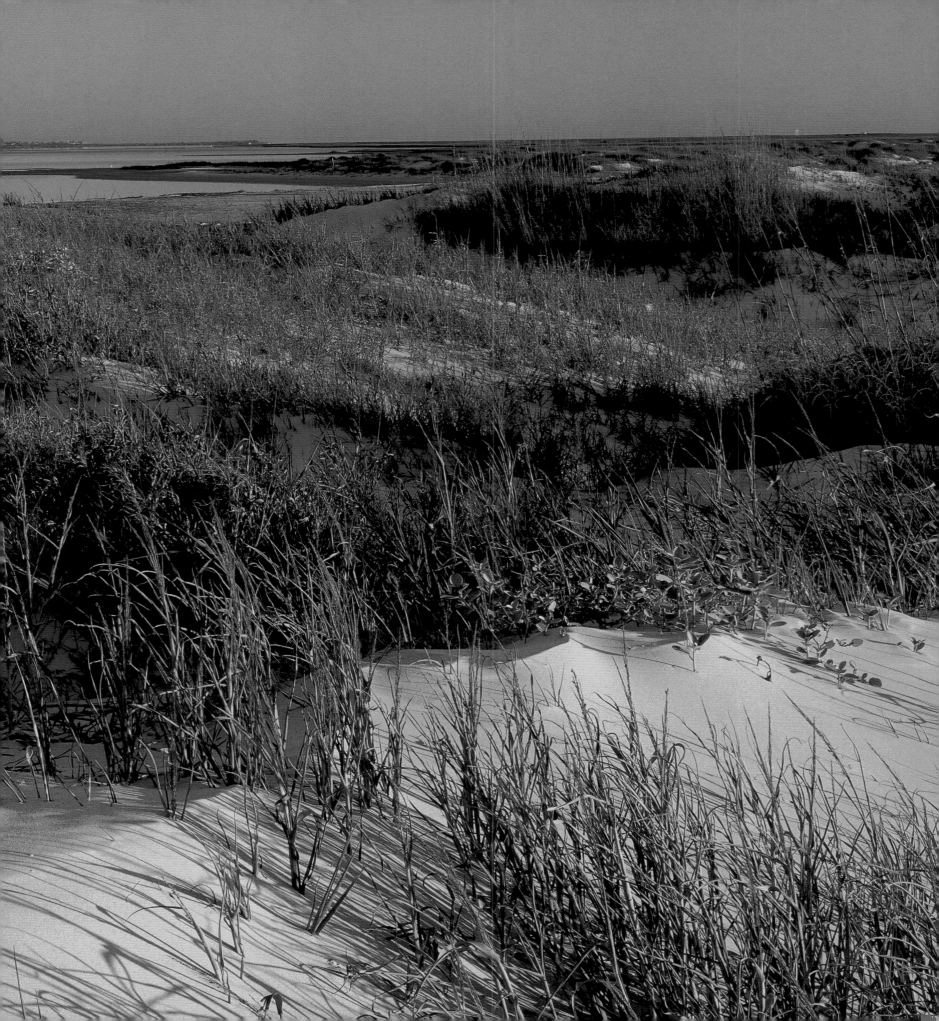

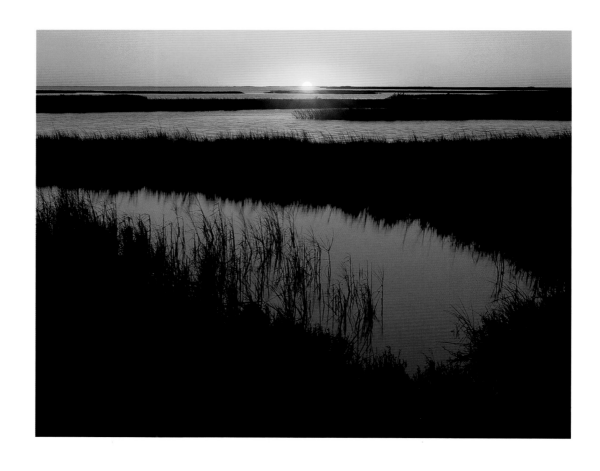

*Salt marshes on Espiritu Santo Bay, Matagorda Island*

PRECEDING PAGES: *Matagorda Island State Park and National Wildlife Refuge*

*The middle part* of the Texas coast is defined by an abundance of creeks and rivers flowing into the bays, features that the new settlers who began appearing in the mid-nineteenth century found appealing, even though many of the towns established here never really took root.

This is some of the richest land in Texas, exceptionally fertile soil that can yield two, even three harvests in a given year. The lush coastal grasses are ideal for cattle, and giant forests of oak, pecan, pine, and sycamore shelter an abundance of wildlife.

*Sargent,* a scattering of maybe a hundred dwellings on stilts, is in the lost zone of the middle coast. No road accesses the fifteen-mile beach from here to Matagorda. In fact, there is no way to drive the beach until Port Aransas, more than a hundred miles down the coast.

The middle coast isn't exactly the stuff picturesque watercolor landscapes are made of, but there's beauty hidden in the industrial sweep of refineries, offshore drilling platforms, and bad development. The beach is shallow, like that of the upper coast. The continental shelf doesn't begin to nudge close to the shore until Corpus Christi.

Salt air dominates here. When mixed in with the pungent odors of paper mills or the earthier aroma of petrochemical refineries, the damp, dank smell of flood becomes almost pleasant. At night, fog and artificial lighting decorate chemical plants like so many twinkling Christmas trees, lending a warm, fuzzy glow to the black sky.

*Palms,* the surest signs of humankind's ideal of what a coast should be, materialize around Sargent, even though they look out of place in the scrubby mesquite flats.

This part of the coast is proudly rural. A beauty shop on FM 2611 advertises ALL RACES on a sign posted out front. Balers, harvesters, and tractors poking along the two-lane blacktop slow traffic in both directions. A sign identifies Matagorda, established in 1827, as the CRADLE OF THE TEXAS SEACOAST. Grain bins are everywhere. Two men sit in lawn chairs next to their pickup truck, five rods planted in the sand, waiting, watching, meditating. A man in a tower scans the canal to engage the drawbridges over the Intercoastal.

The area is highly industrialized. Power lines strung along the coastal prairie like spiderwebs crisscross a maze of

railroad tracks that inevitably lead to big plants adorned with tanks, towers, catwalks, stairways, scaffolding, and tall stacks emitting flames of fire, invisible jets of steam, and plumes of smoke, all containing substances that are not likely beneficial to inhale. The perimeters of the plants are bordered by high chain-link fences topped with barbed wire and razor wire.

*On the south side* of the road to Matagorda Beach is a crowded strip of vacation hovels and funky fishing shacks on stilts fronting the banks of the Colorado River. Many are damaged or destroyed. Piles of trash, trees, brush, lumber, refrigerators, and twisted metal line the roadside, all of it disturbing evidence of the visit by a storm named Claudette two months earlier. Save for the sign out front, nothing whatsoever remains in the lots where the However, Whatever Fishing Lodges once were. The piles grow larger as you get closer to the beach.

North of the road to Matagorda Beach is a gorgeous, uninterrupted sweep of green marsh and blue sky speckled with the brilliant white of cattle egrets and the bright pink of roseate spoonbills. The marsh appears pristine and undisturbed, showing no sign that a severe storm has ever blown through.

On the beach, one in five shacks has storm damage. Screens are ripped, shingles torn, siding frayed. Exposed insulation pooches out like an overstuffed bale of cotton. Men on roofs hammer away. They are playing out the healing part of the storm event ritual, demonstrating the resilience of humans, their determination, will, and blind faith in the face of the inevitability that another storm will someday pass this way.

The beach is littered with huge pieces of driftwood, brush, and seaweed. The pier leading to the north jetty is closed, trashed by the relentless surges that finally ripped it apart and left a giant hardwood wedged beneath the pilings. The sand is typical of the upper coast, hard-packed, deeper brown in color, comprising fine grains bordering on mud, rife with shell detritus.

The ground in some bar ditches is so soft that poles tilt awkwardly, like a drunken army of leaning towers of Pisa. A caracara, the lean black falcon with a white head and white wingtips—known as the Mexican eagle because it adorns the flag of Mexico—picks at roadkill. A swarm of blackbirds descends on a field of sorghum.

Collegeport is more than half empty. The town with a post office the size of a small postage stamp was established in

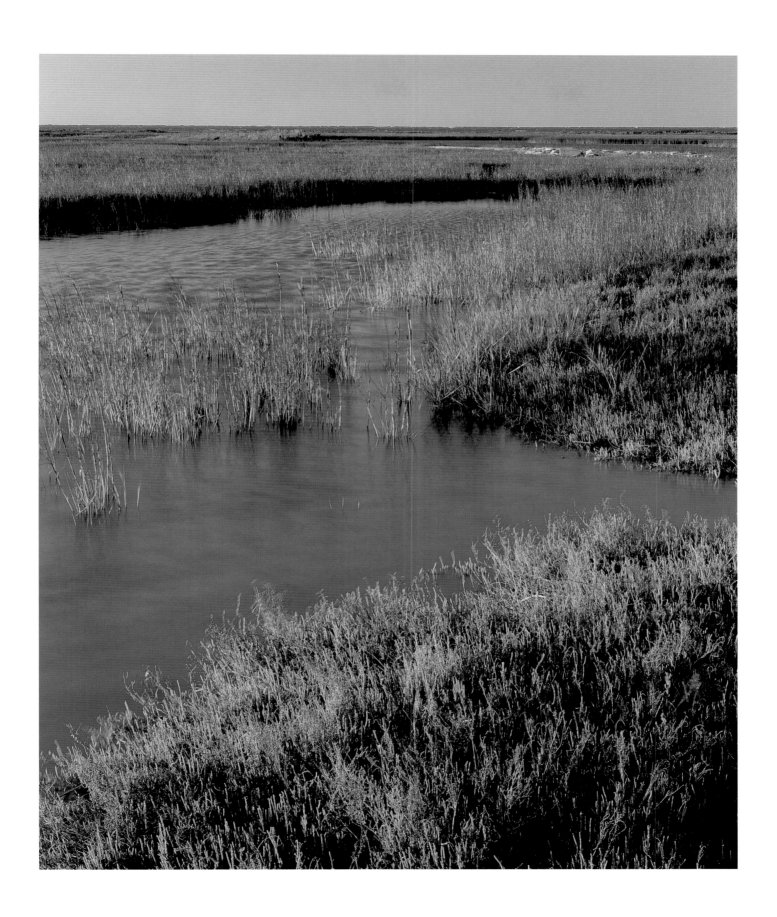

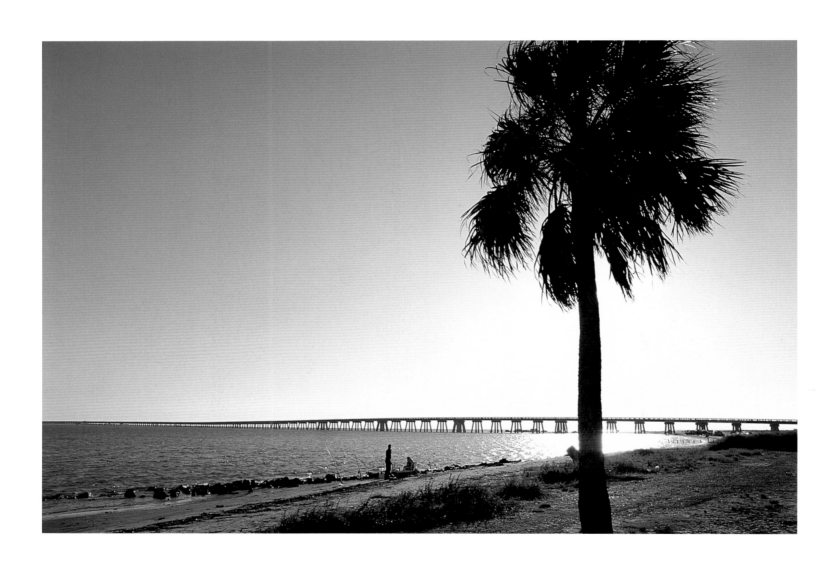

San Luis Pass County Park

*Beach dunes and sea oats with tracks, Matagorda Island*

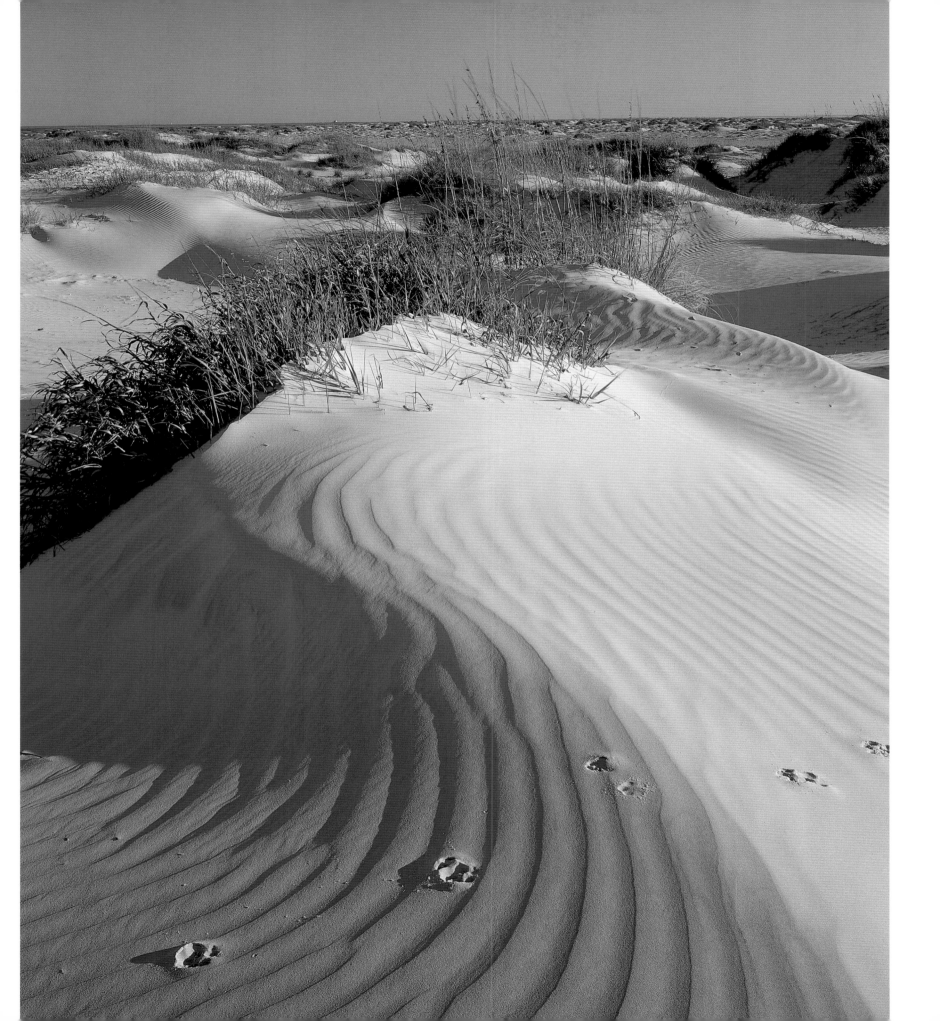

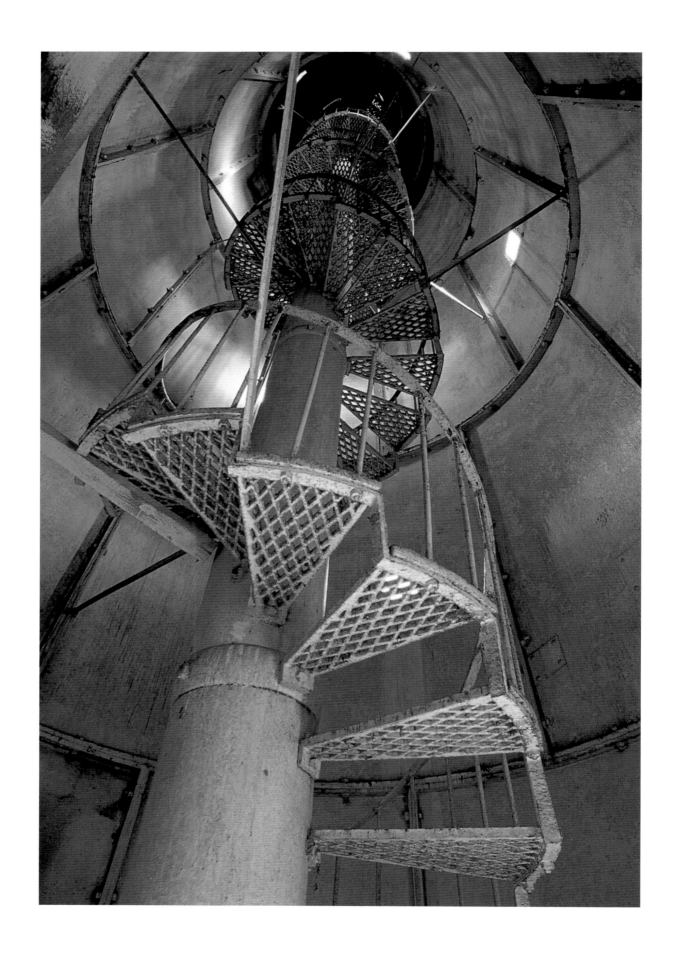

1902 on a nine-thousand-acre piece of the Pierce brothers' ranch with a college, the Gulf Coast Institute of Industrial Arts, a port on Trespalacios Bay, and rail service from the Missouri Pacific line. Twelve years later, a killer freeze struck, followed by extended drought that was exacerbated by livestock disease. The town never recovered. Sunday services are still held in the white, steepled, cinder-block Presbyterian church that grew out of the town's original house of worship, which ministered to fourteen different faiths when it was organized in 1909.

Hawks and eagles circle silently overhead, surveying the edge of the bay, oblivious to the unrealized vision of a planned community.

*If any part of the Texas coast* is haunted, it is the area around Indianola. A bait shop, several houses, a line of blue-framed picnic shelters, and an eroding beach that is being shored up by installing pilings and hauling in more sand are the only hints that this shorefront overlooking Lavaca Bay was once a major port.

The Calhoun County Historical Society placed fifty blue markers along the waterfront to fill in the blanks about the most important port of entry for immigrants to Texas. Germans under the direction of Prince Carl Solms-Braunfels began arriving in 1844, headed for New Braunfels and Fredericksburg, though many of the new arrivals decided to settle in Carlshaven, as they called Indianola. One of the markers notes that the first immigrants were "subject to ever changing elements and the attacks of the Gulf Coast Mosquito," confirming that some things never change.

More than five thousand immigrants arrived in thirty-six ships during 1845 and 1846. The port started to thrive in 1846, the same year that outbreaks of typhoid, cholera, and spinal meningitis killed almost two thousand residents. Steamships from New Orleans and Galveston arrived every five days. Troops returning from the Mexican War gathered at the port, and a stagecoach line and trade route to El Paso were established, then extended to California with the gold rush. At one point Indianola's town plan had 834 building blocks, 64 wharf lots, and 142 farm lots, each ten acres in size.

In 1851 the elements began to have their way. A short but severe storm injected salt water into the town's freshwa-

ter cisterns. Wharves were badly damaged. Two years later, a yellow fever epidemic hit. Still, the town rebuilt and prospered as never before, growing to a population of five thousand before a destructive hurricane struck in 1875. Another powerful hurricane in 1886 proved to be too much, and by 1887 the site was abandoned.

*Port O'Connor,* close to the mouth of Matagorda Bay, knows its sense of place. WE CAN'T HIDE OUR DOLPHIN PRIDE, declares a sign in front of a local school. It shows. Port O' may never have caught on as an industrial port or a beach destination, but its proximity to the bays and the Gulf has brought a tide of prosperity in the forms of recreational boaters and sport fishermen. The town is well aware of its history. Several businesses bear the name La Salle, in honor of the French explorer who established Fort St. Louis nearby, only to have the town mysteriously vanish just a few years later. But Port O' clearly lives in the here and now. The homes and mobile home residences look newer, the docks sturdier, and the fleet of shrimp boats shinier than those of the neighboring towns of Port Lavaca and Seadrift.

The countryside beyond the city limits is classic coastal ranching country, where Brahma cattle, the humped breed that originated in India, graze contentedly among mesquite trees so prodigious that the landscape looks like a part of the Tamaulipan Thorn Forest that flourishes in the borderlands to the south.

The Haws family knows this coastal prairie. For more than a hundred years they ranched cattle on Matagorda Island, through its incarnation as an air base and a bombing range, until it was bought by the state and declared a park. Mainlanders now, family members are still bitter about being removed from the barrier island. To them, Matagorda will never be the same.

A ferry operated by the Texas Parks and Wildlife Department shuttles visitors, campers, hikers, bikers, and school groups to the island from Port O'Connor, an eleven-mile trip across Espiritu Santo Bay. The first visible landmark on the island is the 110-foot cast-iron lighthouse. Several outbuildings on the bay side of the island near the ferry landing are remnants of the abandoned air force base.

The thirty-eight-mile-long barrier island is about as close to a shoreline wilderness as you can get on the middle coast, and it's not the kind of place meant

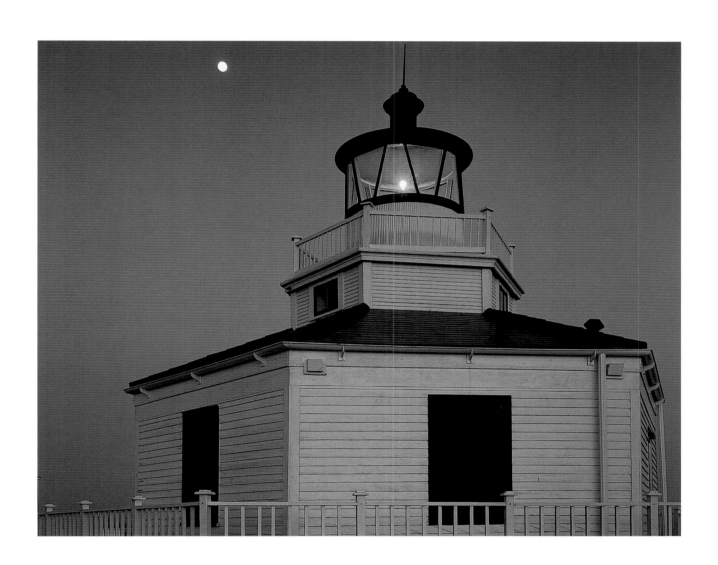

*Halfmoon Reef Lighthouse, Port Lavaca*

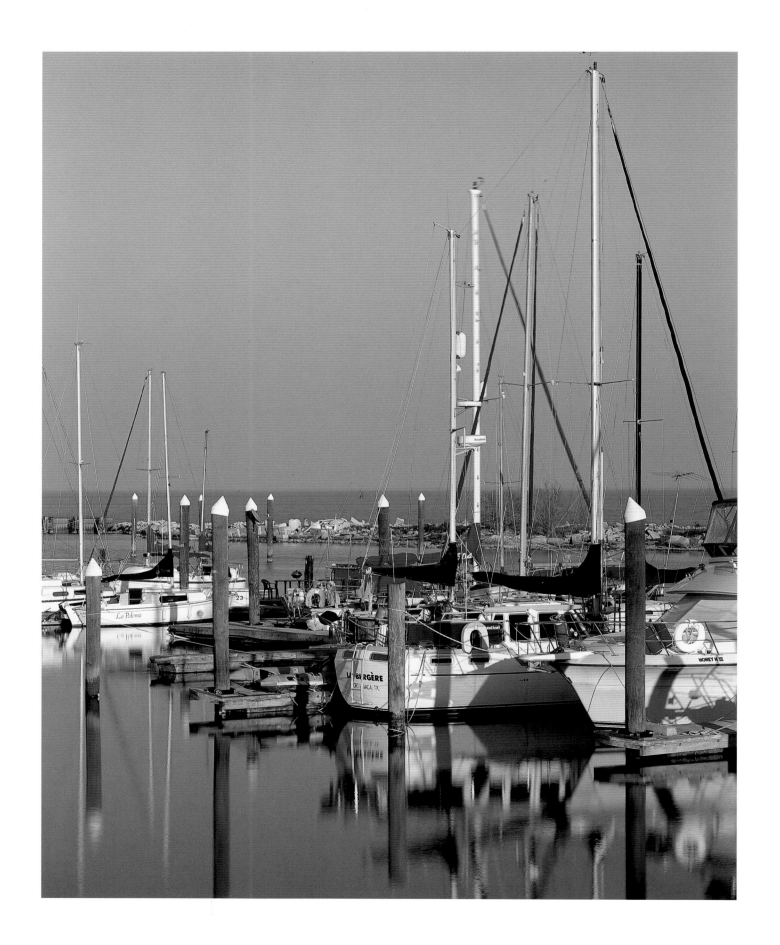

for humans. Thriving in the vast fields of bluestem and sharp saw grass are water moccasins, mosquitoes, deerflies, and thorny plants that stick and sting. The island may be regarded as pristine, but it is no stranger to human activity. Several trenches dug during the Civil War are still visible. One provided protection for Union soldiers from a Confederate garrison at Fort Esperanza, which the outnumbered rebels eventually abandoned. The grasses were grazed by cattle for 150 years, then for several decades the air force attempted to bomb the island into the sea as part of practice exercises.

Now Matagorda belongs to the wildlife. An elevated platform offers an expansive view of a marsh where red-winged blackbirds chitter and chatter and a couple of black-headed coots loiter in the grass. An eastern meadowlark and two cedar waxwings glide by. A whistling tree duck emerges from the water. Endangered least terns nest in the cracks of the abandoned runway. Three hundred twenty-five species of birds in all, nineteen of them protected or endangered, including whooping cranes and peregrine falcons, have been recorded on Matagorda. The herd of white-tailed deer on the island numbers close to a thousand.

*Seadrift* on a weekday winter afternoon: Vietnamese kids hanging on the steps of St. Patrick's School of Religion. The increasingly duct-taped condition of housing the farther one gets from the water. The sweeping views of the waterfront from Bay Avenue. Birds and sailboats bobbing in the rough bay. A small fleet of shrimp boats at the docks. The promise of the Harbor Inn: YOU CATCH 'EM, WE COOK 'EM. A purple wood frame house overlooking San Antonio Bay.

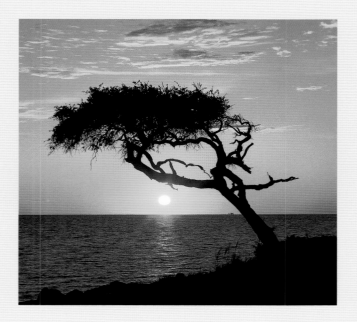

*Harbor with sailboats, Port Lavaca*

*Live oak on San Antonio Bay,*
*Aransas National Wildlife Refuge*

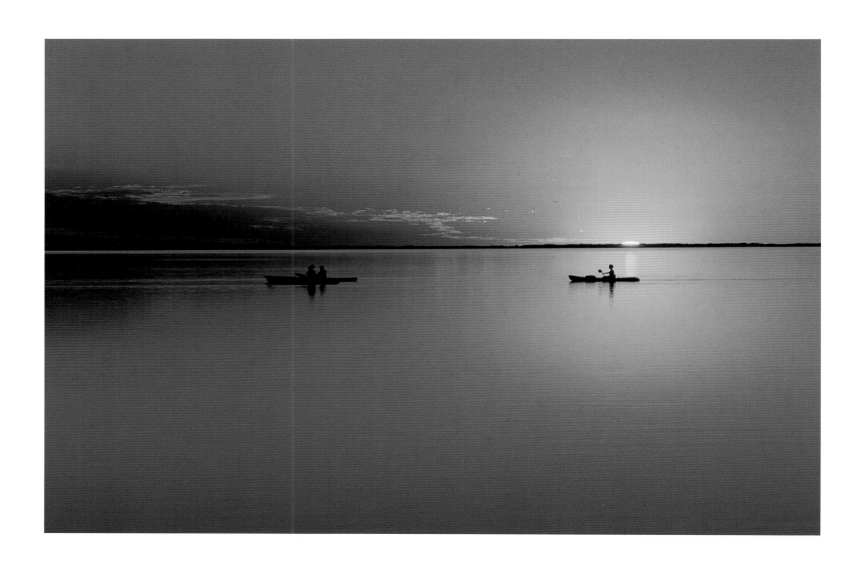

*Kayakers at sunset, Laguna Madre*

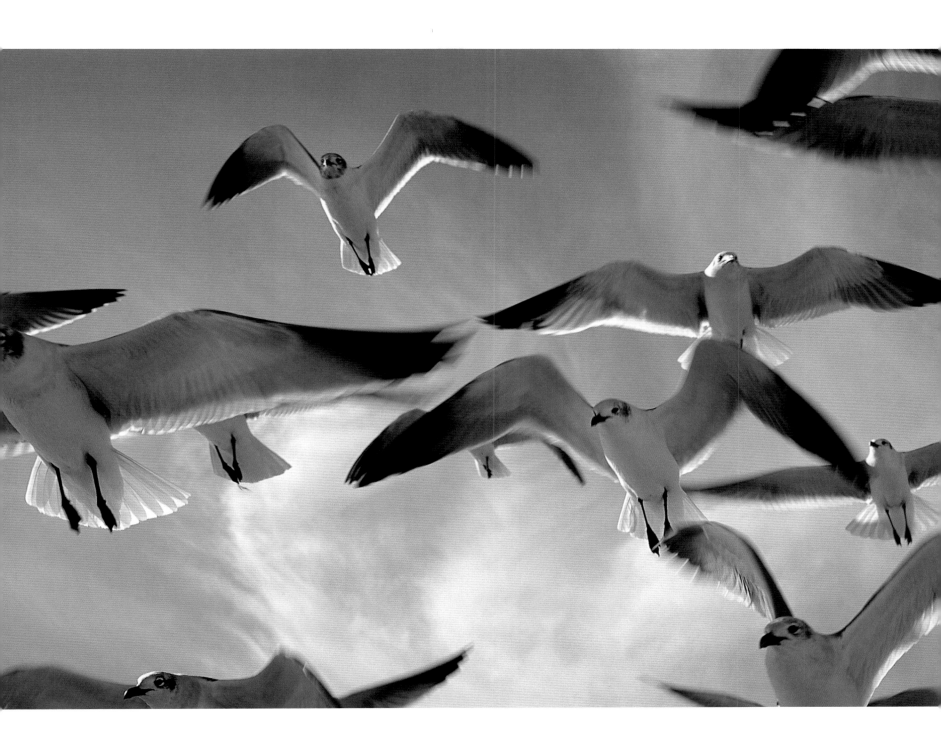

*Seagulls, Port Aransas*

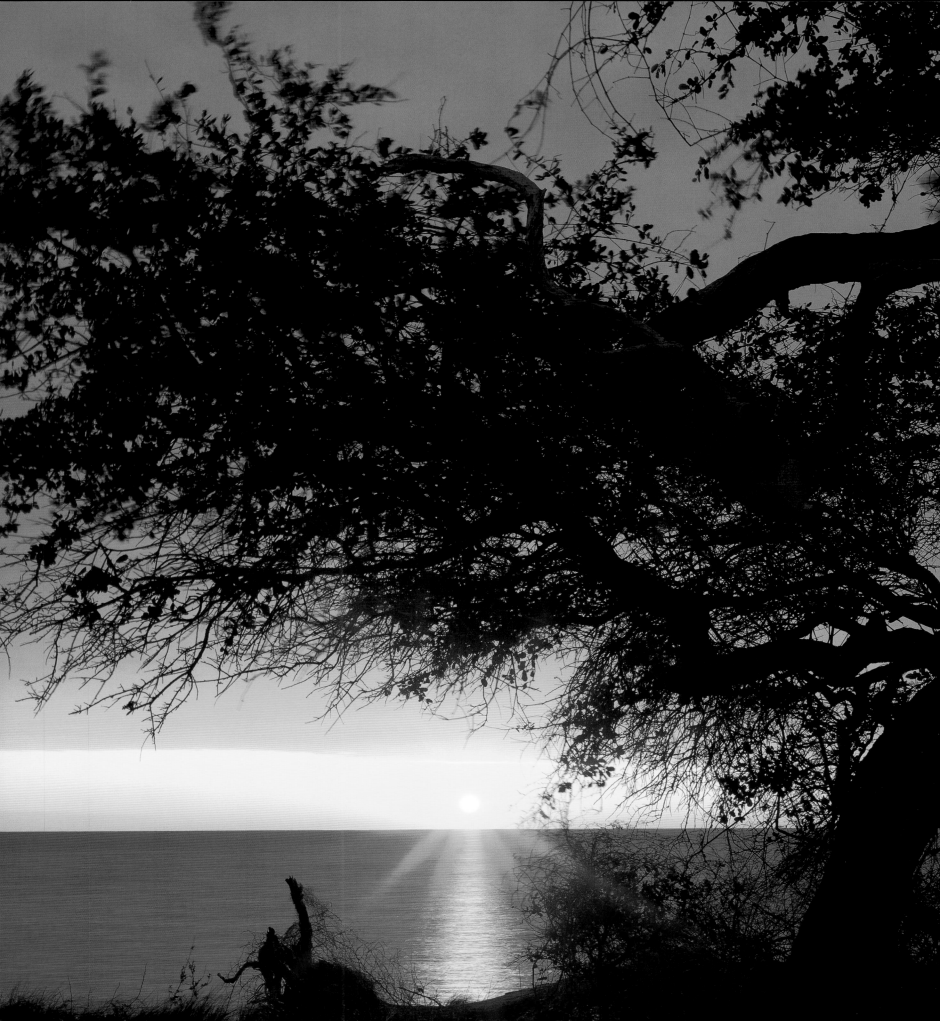

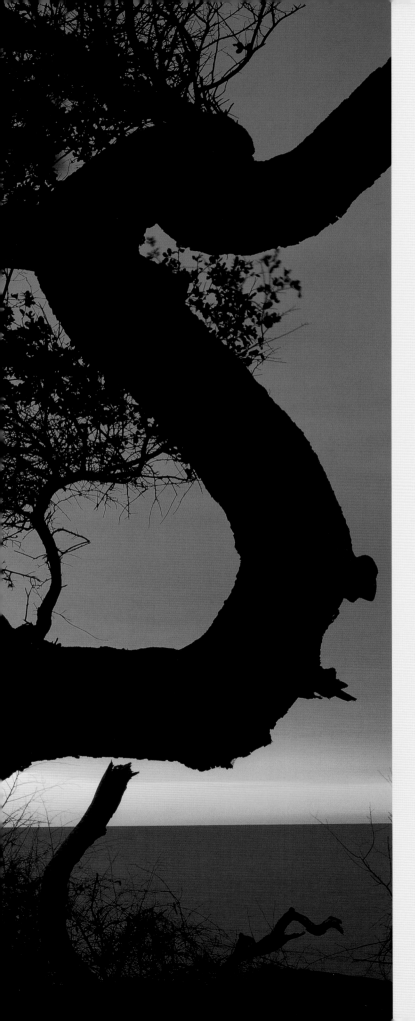

*The Aransas Prairie* is defined by wind-swept oaks. The oaks of the coastal prairie are not tall, rarely more than twenty feet, but are sculpted magnificently—bent, twisted, shaped, and curved by the constant Gulf breeze. They are found in their fullest glory on Goose Island on the Lamar Peninsula, where they grow increasingly larger and more gnarled and more twisted along Park Road 13 until, just before water's edge at St. Charles Bay, there it is:

The Big Tree. The Goose Island Oak. The Lamar Oak, a coastal oak, a live oak, a coastal live oak, the Bishop's Oak. *Quercus virginiana Miller,* to be exact.

Maybe thirty feet tall, with a trunk more than thirty-five feet in circumference and a perfect broccoli crown that spreads eighty-nine feet, the Big Tree was made for climbing—though a chain-link fence discourages that. Three sagging lower limbs, propped up by metal posts, show her thousand-year age. Regardless, she is constantly admired by throngs of pilgrims and flocks of birds riding the sea breeze. The wind compliments her beauty by playing a soft melody as it passes through her branches.

Rockport, the town just south of the Big Tree, was once a sleepy little art colony famous for its wind-shaped coastal oaks and shrimp fleet. Toward the end of

*San Antonio Bay, Aransas National Wildlife Refuge*

57

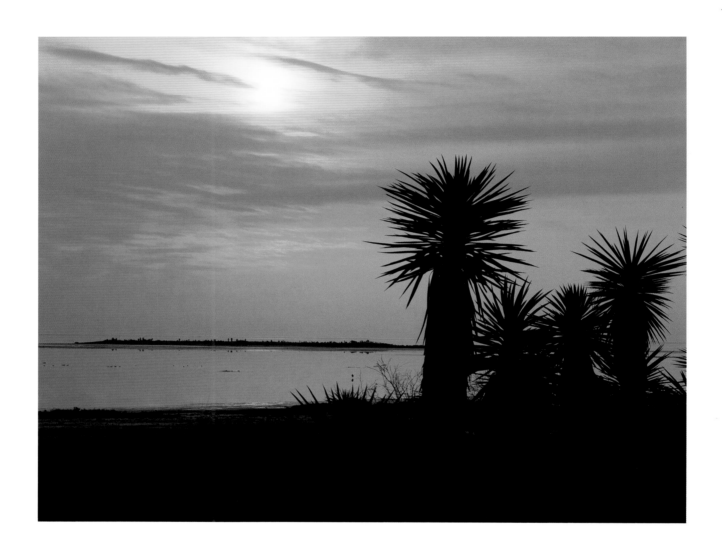

*Sunrise, Laguna Madre*

*Live oaks, Goose Island State Park*

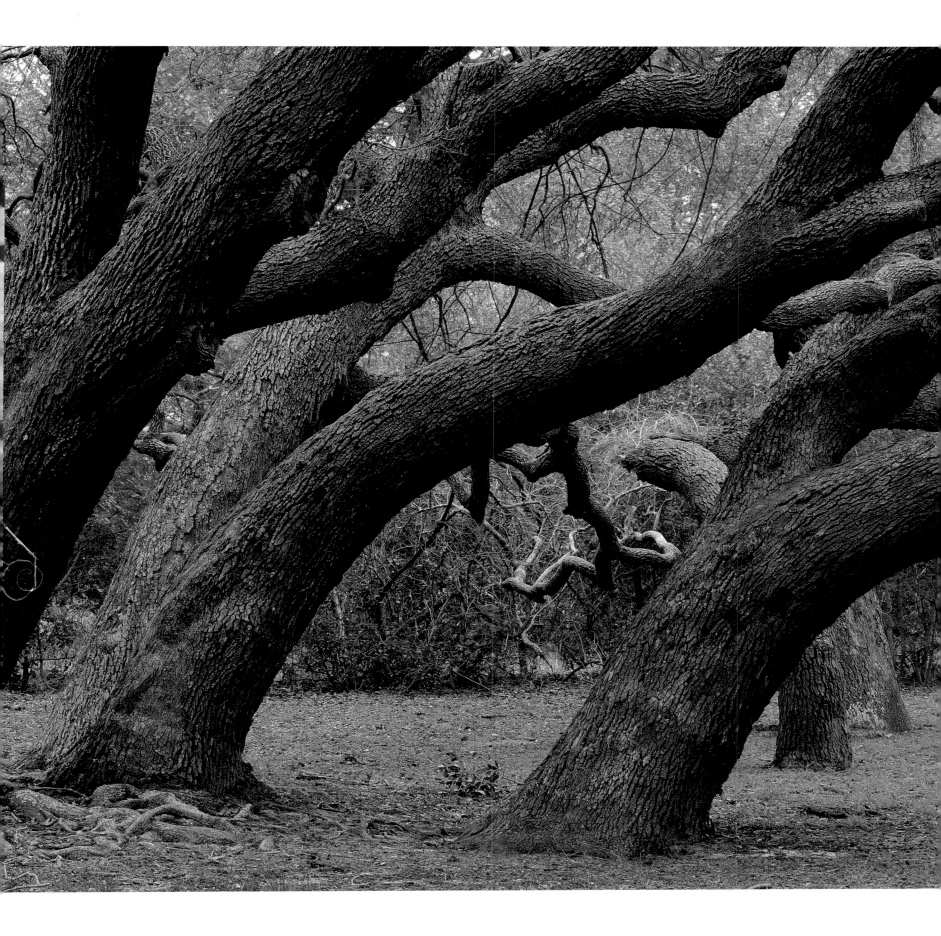

the twentieth century it reinvented itself. These days Rockport is better known as the most popular departure point for boat tours to see the whooping cranes, the biggest bird in North America; two hundred of them, the last surviving colony, spend the winter in the bay flats around the Blackjack Peninsula and Aransas National Wildlife Refuge (no fools, the big birds spend the summer near the Arctic Circle).

The town has developed another rep as well; it's the place to go for stalking red-fish in the flats with a fly rod, which translates into the ultimate hunting experience in Texas waters. With a shallow draft kayak and no motor on a clear, calm morning, it is relatively easy to enter hidden back bays among the marshes and mangroves and sneak up on redfish, the National Fish of the Texas coast. There it is, its tail out of the water while it feeds on shrimp. Aim a fly on top of the tail and a vicious fight ensues, a fishing experience comparable to pursuing bonefish in the Caribbean.

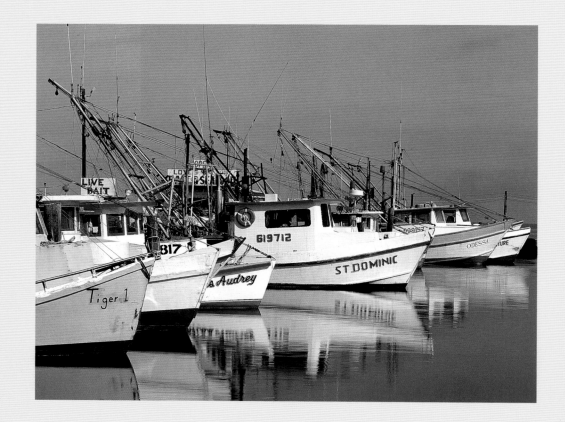

*Shrimp boats in harbor, Fulton*                    *Fulton Mansion State Historical Park*

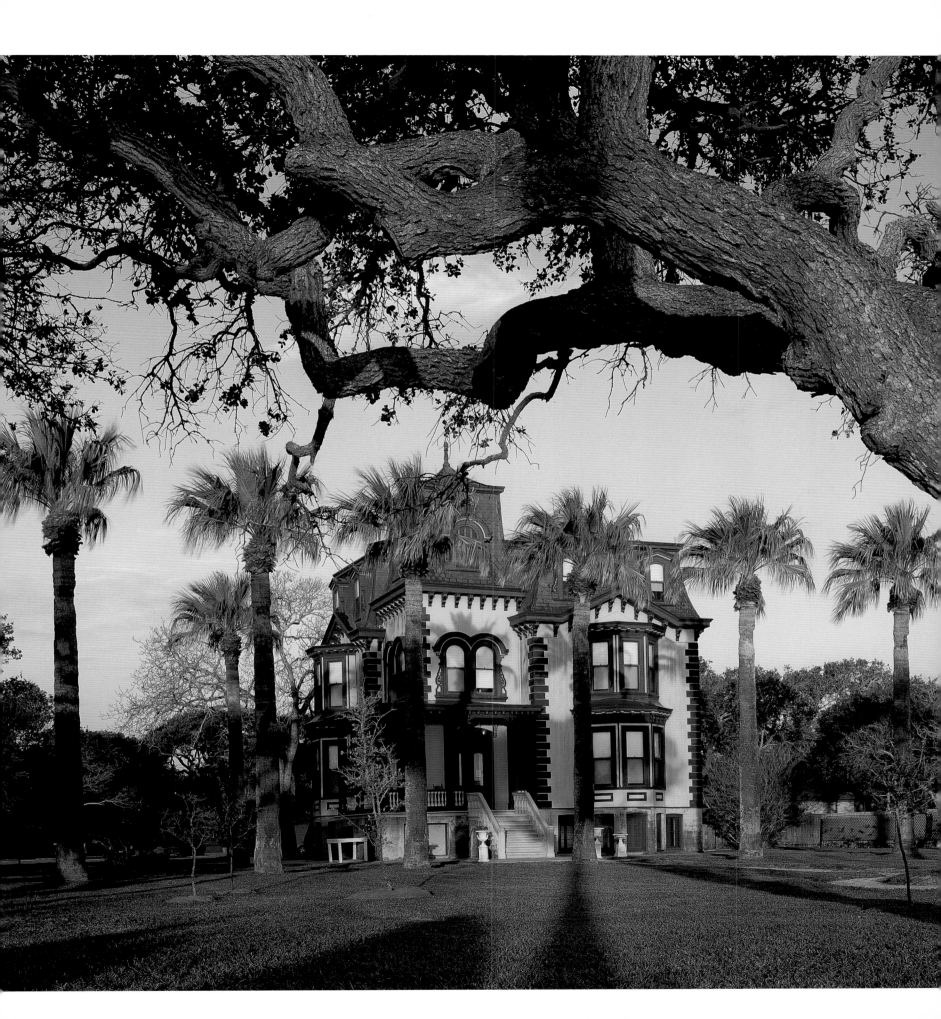

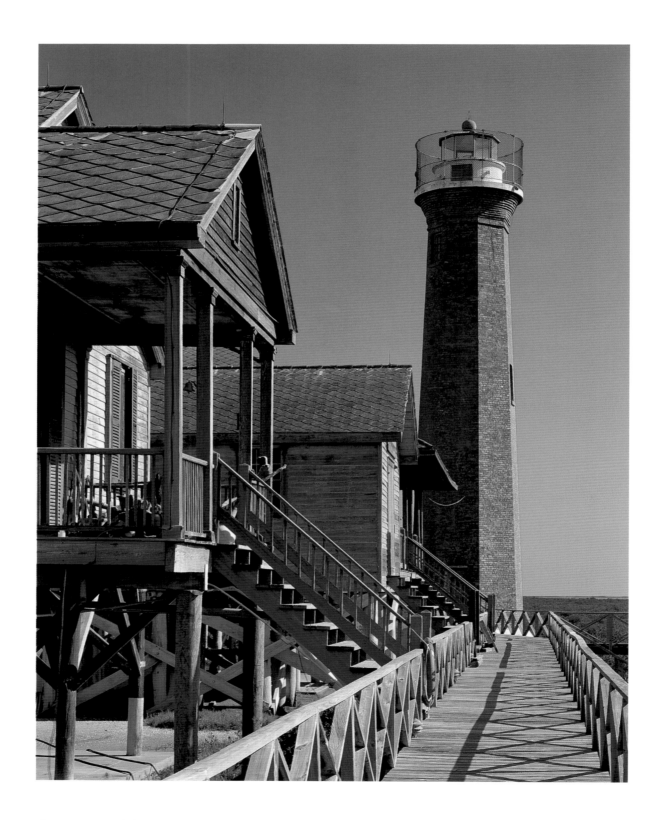

*Aransas Pass Lighthouse, Port Aransas*

*There are three hot zones* for sunrise shelling on the Texas coast. San Luis Pass, at the mouth of West Galveston Bay, is known for lightning whelks (the official shell of the State of Texas), cockles, and wentle-traps. Mussels, sand dollars, and conchs are abundant on San Jose Island, which is owned by the Bass family of Fort Worth. Conchs, sand dollars, and Gulf clams are plentiful at Big Shell Beach between mile markers 22 and 27 at Padre Island National Seashore.

*Fourteen lighthouses* have guided ships from sea to harbor along the Texas coast since the early 1800s. Four still perform their intended navigational function. Twenty-three keepers have been responsible for maintaining the Aransas Pass Light Station, latitude north 27 degrees 51 minutes, 51 seconds, longitude west 97 degrees 3 minutes, 25 seconds, on Harbor Island, 1.2 miles north of the town of Port Aransas, Texas, in the lagoon called Lydia Ann Channel. Twice a day the keeper climbs its spiral cast-iron stairs to flip the switch of the Phillips 400-watt bulb that illuminates the 375 mm fourth-order Fresnal lens.

Though officially a private navigation aid, the old brick tower variously known as the Aransas Pass Light Station, the Lydia Ann Lighthouse, and the St. Joe Light re-mains the beacon of the Coastal Bend. The sixty-eight-foot-tall octagonal tower and several adjacent unpainted, weather-worn wooden structures on stilts are perched at the edge of a salt marsh.

Construction of the lighthouse began in 1854. The bricks came from Pascagoula, Mississippi. The French lens was lit three years later. The only light of any kind in the region for decades, it was operated and staffed by the men of the United States Lighthouse Establishment.

During the Civil War, Confederates buried the lens in the sand out of fear that Union soldiers would seize the pass. A new lens was installed in 1867. Various structures have been built alongside the lighthouse over the years: the main house in 1919, the same year the lighthouse was rebuilt; the shop in the 1920s; the north house in 1920, with add-ons completed in 1939. The Coast Guard deactivated the lighthouse in 1952 after a major channel shift led to the erection of a taller, steel-framed tower on Port Aransas, and the lighthouse and the land around it were auctioned off. The property was bought by Adele and Jack Frost from Sweet-water in West Texas, who used it as a retreat. Charles Butt, of the H-E-B grocery family, bought the lighthouse in 1973 and initiated its ongoing restoration.

The wood is longleaf pine, the most durable and sturdy of pines, now all logged out. The doors and windowsills were hewn of cypress. The roof decking is one-inch-thick tongue-and-groove, toenailed with copper fastenings. The roof tiles are made of slate. Workers had to be flown in from Mexico City to replace them. At one time five families lived in the main house, with a single two-hole outhouse out back. The kerosene from the generator and the eau-de-outhouse gave one keeper's wife fits.

*The cluster of lights* around the ferry crossing leading to Port A looks like Christmas on a foggy, cloudy November evening. Summer is a distant memory, and the winter snowbirds have yet to arrive. The ferries are all but empty, with only two, the *Arnold W. Oliver* and the *J. C. Dingwall,* plying the channel and no waiting lines in either direction.

One could wax idyllic about the crossing, if not for the fences, the ramps, the light posts, and the huge petrochemical storage tanks. Hundreds of shorebirds cluster around both points where highway meets waterway, among them gulls leaving white streaks on breakwater rocks and brown pelicans floating on air above a fer-

ry embarking on its two-minute journey to the northern tip of Mustang Island.

The ferry may seem like a quaint anachronism preserved for the benefit of tourists, who get out of their cars, take pictures, lean over the side scanning the surface for dolphins, and toss crackers to gulls. But it is very much a necessity, since no crossing can be constructed high enough to accommodate both vehicular traffic and boat traffic in the channel, which includes supertankers the height of a twenty-story skyscraper.

The channel is a nexus where various sea interests converge, from tankers to kayaks, with shrimpers, johnboats, cabin cruisers, sailboats, and a gambling ship in between. Lights offshore mark a freighter bound for some distant port, a rigged-out mini-yacht headed for the snapper banks, and a shuttle boat destined for an offshore oil rig.

WELCOME TO PORT ARANSAS TEXAS, proclaims the sign with the jumping marlin painted on the aqua blue storage tank at the ferry landing. Port Aransas— pop. 3,370—is Texas's best-known fishing village, situated at the northern end of Mustang Island, adjacent to the south jetty that designates the entrance to the

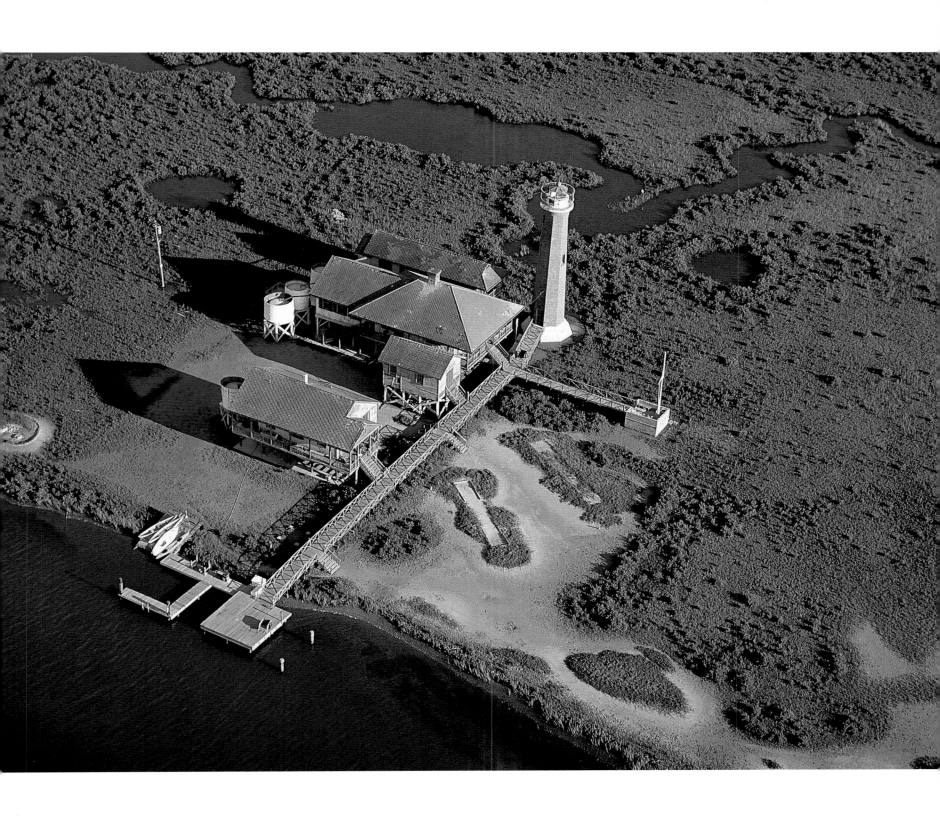

*Aransas Pass Lighthouse, Port Aransas*

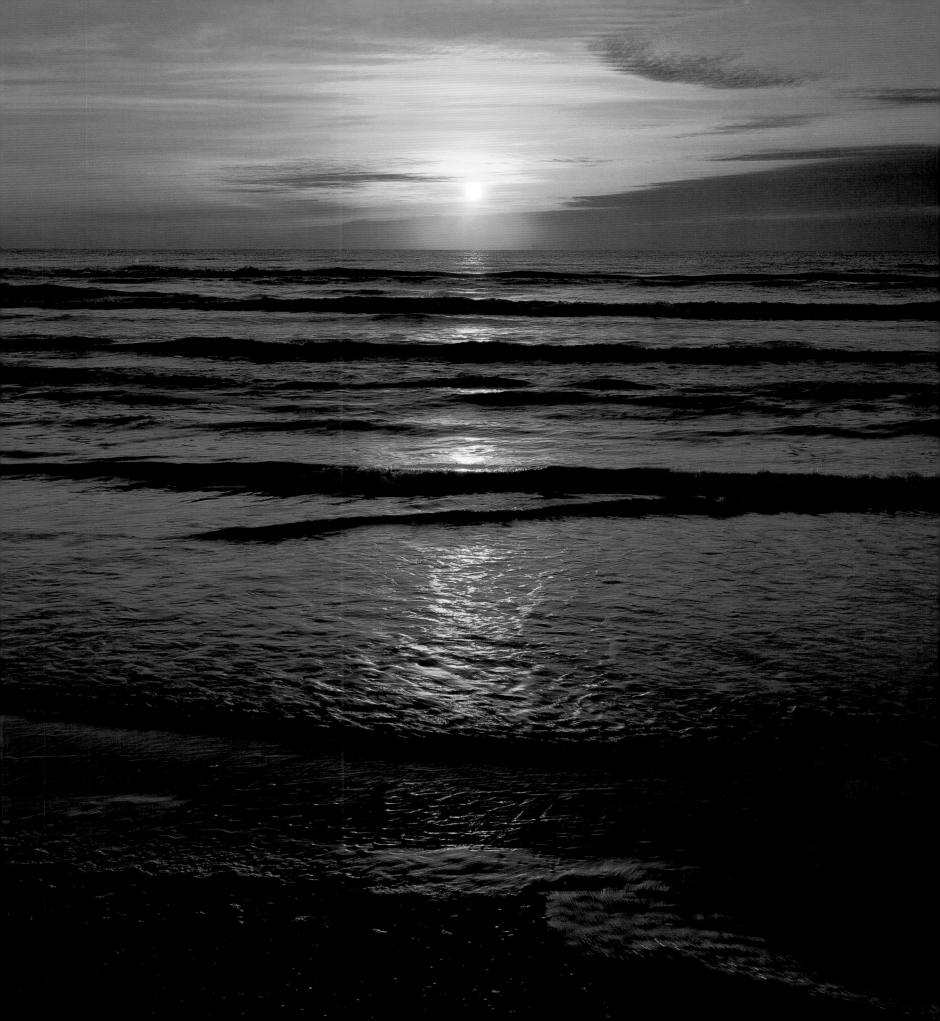

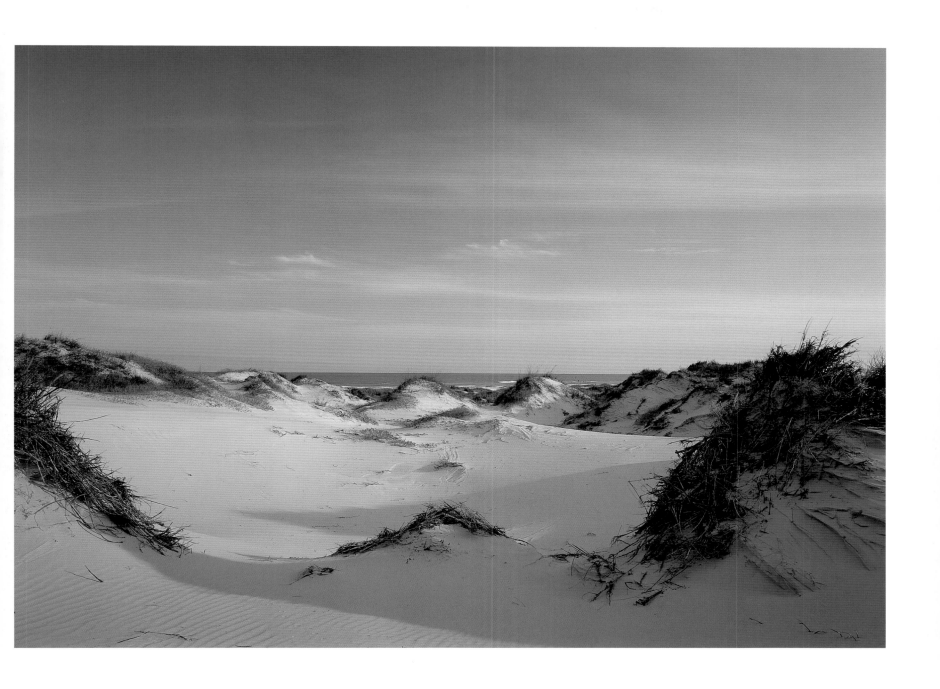

*Dunes and Gulf of Mexico, Padre Island National Seashore*

*Beach sunrise, Mustang Island State Park*

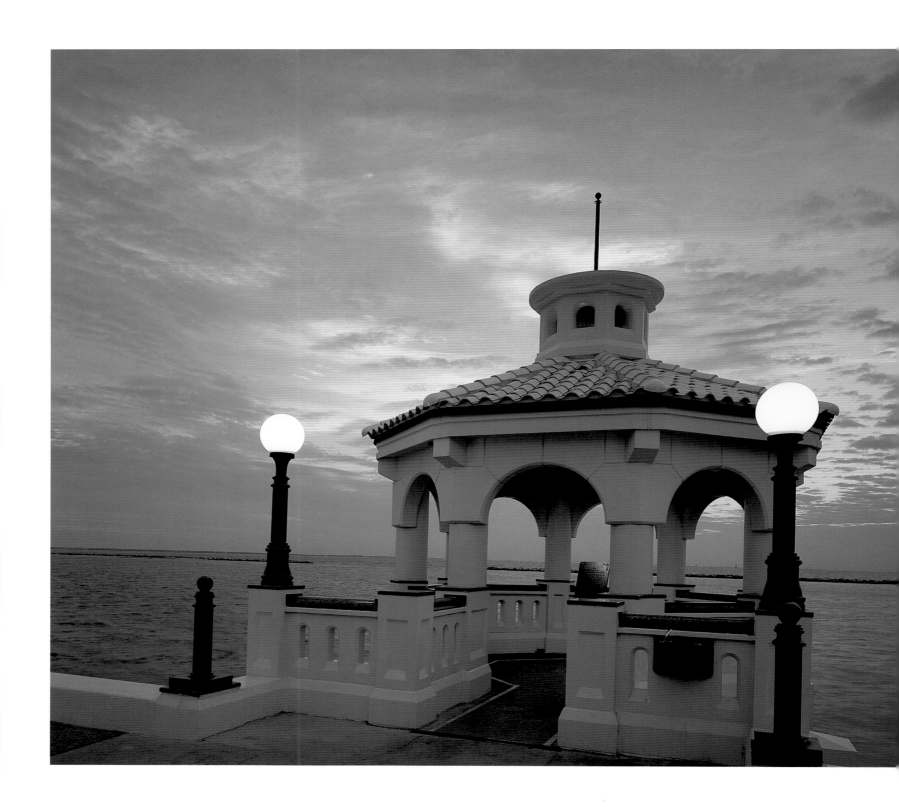

*Mirador on Corpus Christi Bay*

Corpus Christi Ship Channel, where the Gulf meets the bays of the Coastal Bend. Port A has somehow withstood the pressures of growth that come with tourism, recreational fishing, commercial fishing, winter Texans, and shipping traffic to retain its iconoclastic character. As further evidence of that character, note that Port Aransas is one of the few high schools in Texas that do not field a football team. Basketball will do just fine.

Port A is no ecoparadise—there's too much shipping traffic for that, not to mention a town policy of cleaning the beach that actually destroys the protective sand cap that promotes dune growth—but with designated birding areas, bike trails, a public transportation system, several nature preserves, the University of Texas Marine Science Institute, and a community vision statement that vows to maintain the distinctive quality of island life, it comes closer than any other coastal community in Texas.

As the sun descends toward the horizon on a perfectly clear day in late winter, the breezes dying and the warmth fading, water and sky become thick with herons,

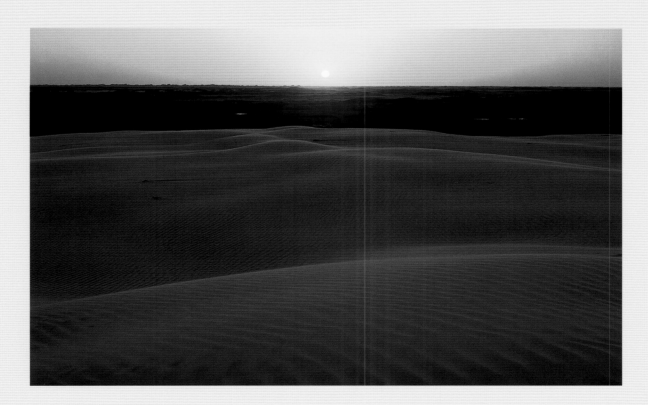

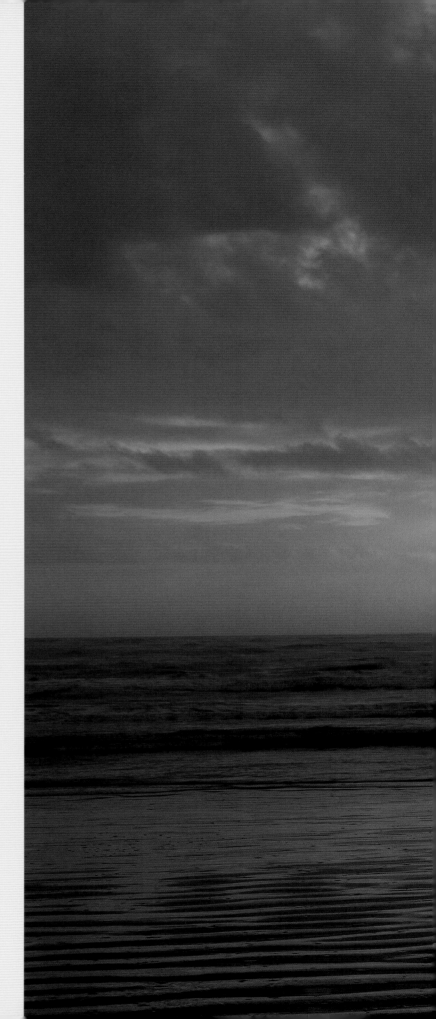

egrets, pelicans, whistling ducks. People bearing binoculars, cameras, and books line the wooden walkway and climb the viewing tower, speaking in low voices. The drama is wherever you look. Two tri-color herons deftly pick their way through the shallows at the edge of a marsh thicket, darting their long necks into the water now and then, seeking to spear an evening meal. Diminutive coots play hide-and-seek in the reeds. Laughing gulls cut loose with their bad brand of humor. Ducks and geese fly past in chevron formation, teals and a lone white pelican crowd the water line, and overhead three roseate spoonbills streak across the sky, their trademark pink feathers burnished red by the setting sun, making for a *Fantasia* hallucination.

As the glowing ball sinks to the horizon, two pelicans settling on the water are silhouetted as they tuck their heads under their wings for the night.

*On the highway* from Corpus Christi to Padre Island National Seashore, modern life gradually peels away from the roadside. Convenience stores are the first to go, followed by subdivisions, motels, shell shops, and condos, leaving only telephone lines and poles. Then even they disappear, along with the shoulders of the pavement. The

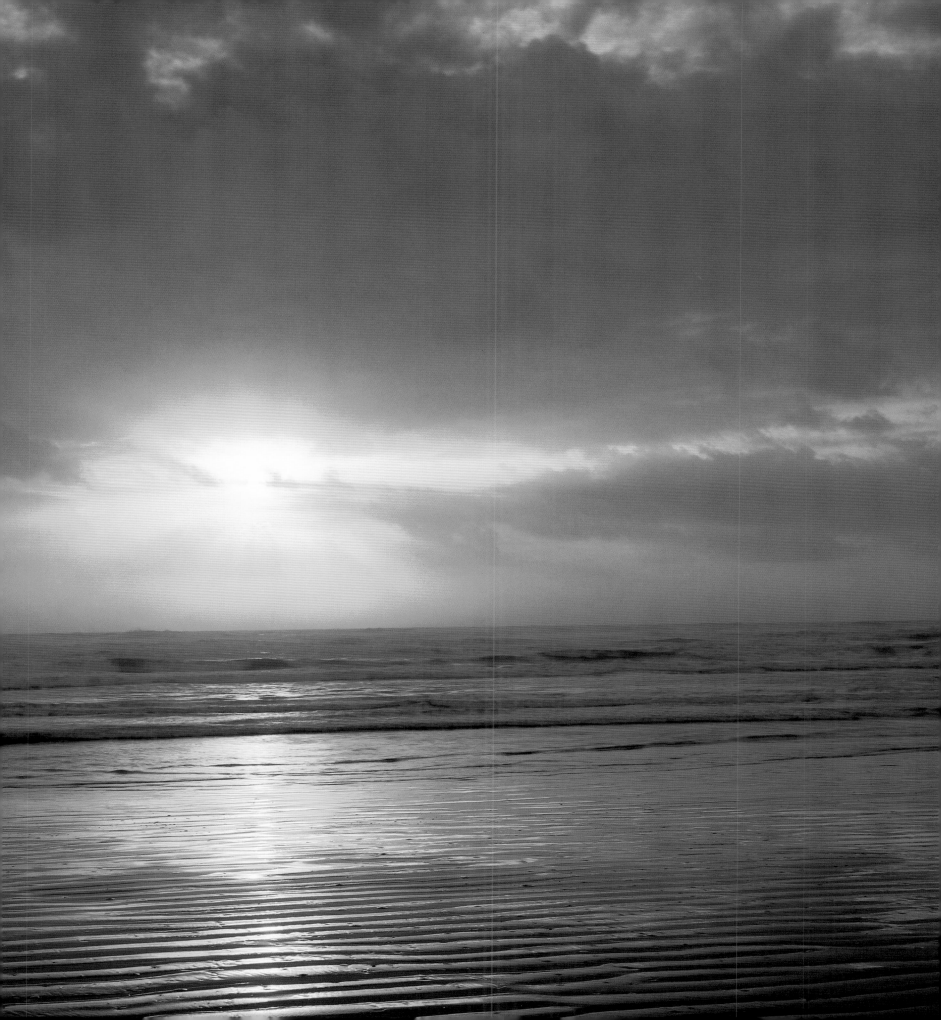

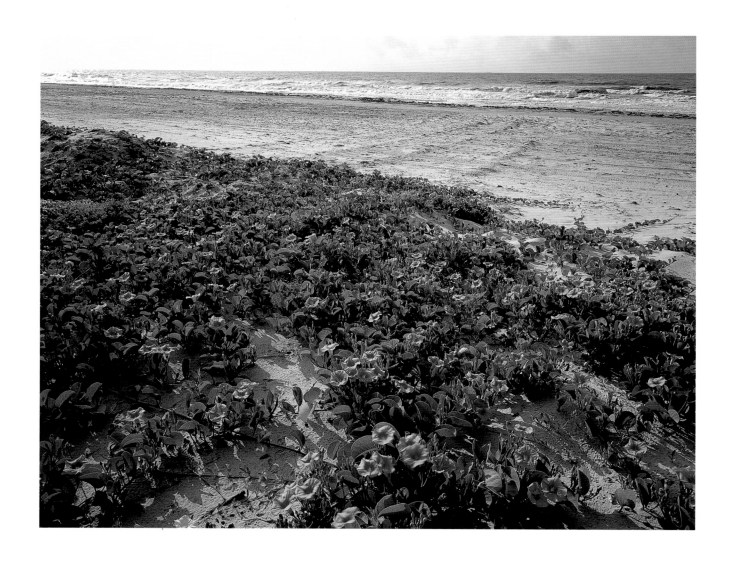

*Morning glories, Matagorda Peninsula*

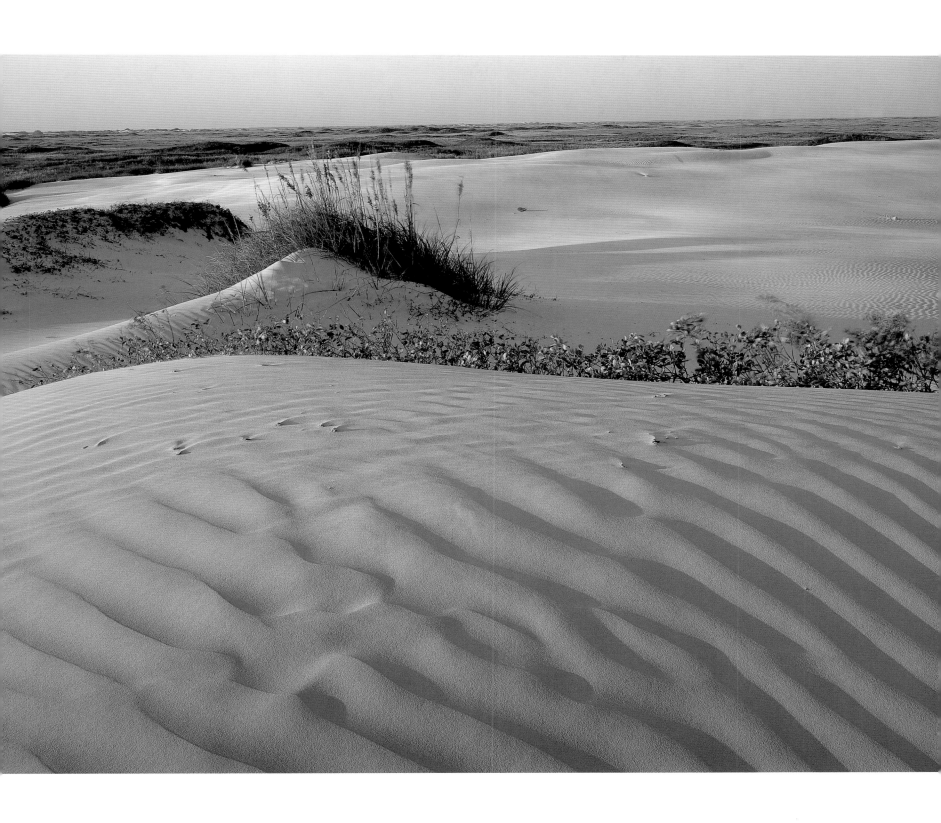

*Padre Island National Seashore*

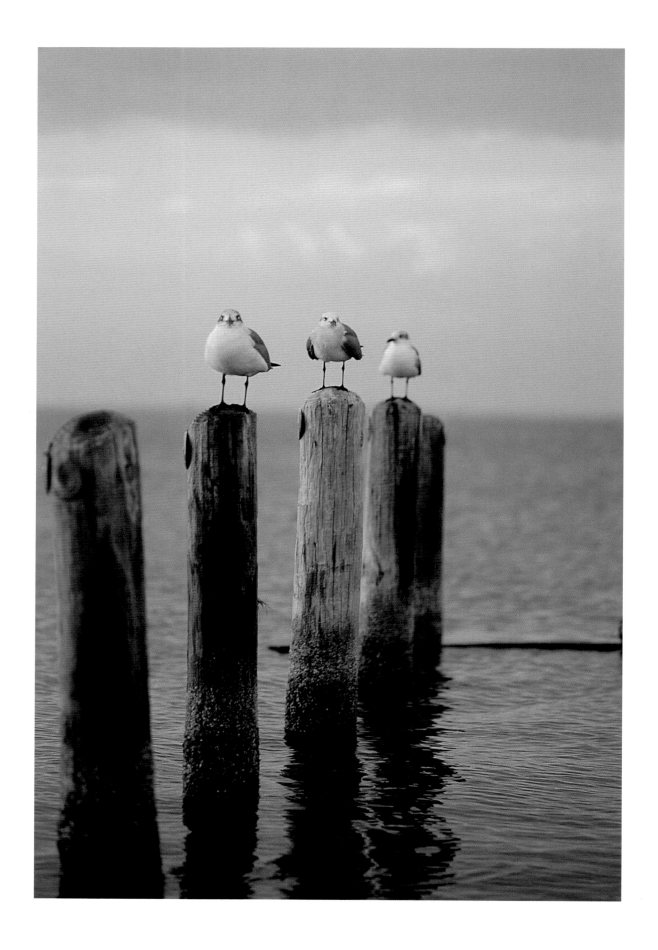

narrow ribbon of asphalt is all that splits the dunes and tidal flats from the sea on what was once the longest barrier island in this part of the world. That was before the Port Mansfield Cut, a man-made channel across the island, was dredged in 1960.

Even the asphalt disappears after the Malaquite Beach visitor center. The beach becomes the road. Perhaps fifty vans and pickups are parked along the first five miles of the national seashore, most of them rigged for overnight camping. Then they too vanish from the windshield view of the southbound vehicle as it negotiates the changing tides and the shifting sands, dodging the debris piled on the shore. Huge ballast buoys, plastic milk crates, trash can lids, bottles and more bottles, telephone poles, a refrigerator, a dead dog, and a card table emblazoned with a green spade are among the washed-up artifacts. A wayward hippie staggers by, seemingly aimless. Where did he come from? Where is he going? Not a vehicle is in sight.

The only signs of life left are all-terrain four-wheelers being driven by park rangers or volunteers on the lookout for endangered Kemp's ridley sea turtles crawling onto the shore to lay their eggs. At mile 27.6 a white pickup truck does a 180-degree turn in the sand. The driver has spotted a Kemp's ridley. The ridley is dead, the flesh around its neck partially eaten away, its four-foot shell covered with moss. The last landmark is at mile 50—an exposed metal boiler in the surf beyond the second sandbar, marking the wreck of the *Nicaragua,* a large merchant steamship that sank offshore in 1912. Mile 60 marks the Port Mansfield Cut, bordered by two jetties extending into the wind-whipped Gulf. Two fishermen in a johnboat moored to the south jetty bob in the waves. Evidence of humanity is everywhere—almost every space between rocks on the jetty is crammed with some piece of plastic, Styrofoam, or metal. But other than the two fishermen, humans are nowhere in sight.

The Padre Island National Seashore became a national park in 1968 with the provision that the minerals underneath the sandy island could be exploited by private interests and by the state. Drilling activity was historically confined to one or two wells on the island until 2001, when several leases were applied for and granted and numerous wells were drilled behind the sand dunes. The arrangement pitted the General Land Office of the State of Texas, which would realize royalties for the Permanent School Fund—"Texas's children," as Land Commissioner Jerry Patterson

liked to frame it—against a user constituency who thought a national seashore meant a seashore free of development and industry. It also threatened the sea turtle recovery program, led by Dr. Donna Shaver and involving several hundred volunteers, that has successfully reintroduced endangered Kemp's ridley sea turtles to the Texas coast by protecting and relocating their nests along the national seashore.

Of the five species of turtles found in the Texas Gulf—leatherback, loggerhead, hawksbill, green sea turtle, and Kemp's ridley—the ridley is most at risk. In 1947, 40,000 Kemp's ridleys were recorded nesting on the beach of Ranch Nuevo, Tamaulipas, Mexico, about a hundred miles down the coast from Texas. In 1967, fewer than 500 were counted. Seventy-five percent of all sea turtles washed up on the beach today along the national seashore have plastic in their stomachs.

The actual drilling platforms on the national seashore are behind the dunes, out of sight and out of mind from the visitors who congregate mostly along the beach. The trucks carrying heavy machinery and equipment are more conspicuous, since they use the same beachfront "road" in the sand that visitors use to access their wells. The rub is that the Kemp's ridleys, as well as other turtles and wildlife, also cross this beach road.

*The lower coast begins* south of Port Aransas, skirting a semi-arid landmass known as the Wild Horse Desert. The region is defined by extended drought punctuated by storms from the Gulf, northers in the winter, and rainy stretches during El Niño events every three to five years. It is mostly dry. Sabine Pass, on the upper coast, averages fifty-five inches of rainfall a year. At the mouth of the Rio Grande, the average is twenty inches. The lower coast system is fragile and subject to brown tides, red tides, and other algae blooms, infestations of sargassum and man-of-war jellyfish, and overfishing. The barrier islands provide a buffer against hurricanes. The bays and marshes are self-fertilizing nurseries for all marine life, and when left alone they function to cleanse the waters of pollutants.

Behind the barrier islands on the mainland is the Brush Country, the forgotten wilderness of North America. Geographically isolated and sparsely populated, the land is often dismissed by travelers passing through as a vast plain of thorny scrub. That's not a bad thing, as long as the travelers keep on going and everyone else leaves it alone, because the region ranks up

*Prickly pear cacti, Palo Alto Battlefield*
*National Historic Site*

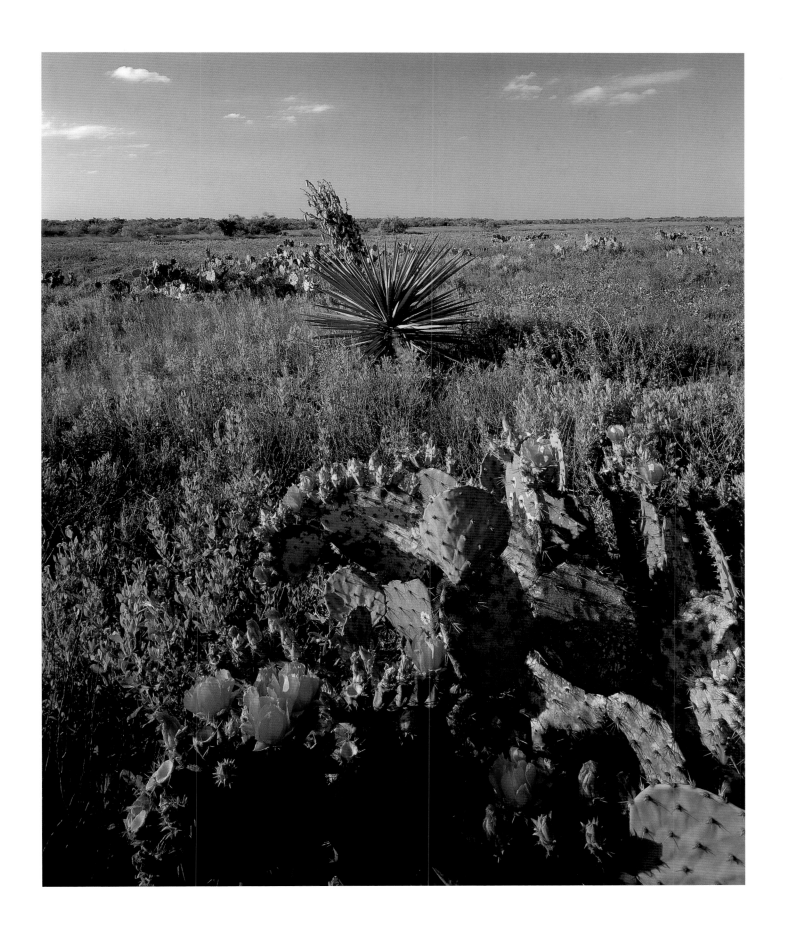

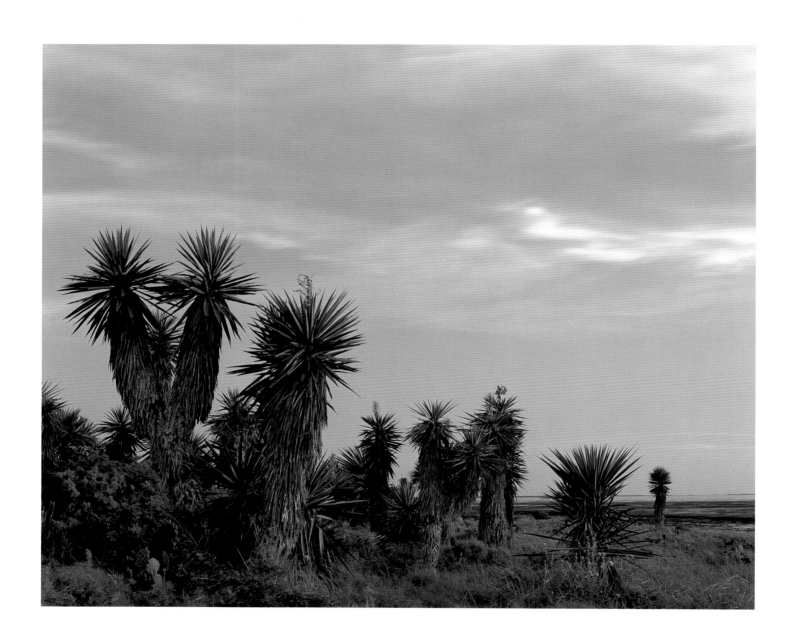

*Laguna Madre and yuccas, Laguna Atascosa National Wildlife Refuge*

there with the Florida Everglades and the sky islands of southeastern Arizona in biological diversity of flora and fauna. In other words, the Brush Country is as critical to the planet's health as a tropical rain forest is. And unlike the Everglades, the Brush Country doesn't need a billion dollars to be saved. It just needs to be left alone.

Most Texans know precious little about the region beyond the King Ranch, the most storied of all Texas ranches, whose existence is a major reason the Brush Country has remained relatively undisturbed. Settled in the eighteenth century through Spanish land grants, the area was not part of the Republic of Texas that broke away from Mexico. It wasn't joined to the rest of Texas until 1848, when the Treaty of Guadalupe Hidalgo ceded New

Mexico, Arizona, and part of California to the United States from Mexico.

Today the lower coast and the Brush Country remain a land of two distinct cultures, Latino and Anglo.

Cowboy culture was born here, with many traditions—among them boots, lariats, chaps, and spurs—adapted from the Mexican vaqueros who drifted north from the other side of the Rio Grande. The Santa Gertrudis breed of cattle was developed here. Great dreams were dreamed here. And they still are.

Vast tracts of land remain as they were two centuries ago. With few oil and gas reserves, the land has not been exploited for its resources. Cattle raising, which historically provided the primary source of income for landowners, is being supplanted

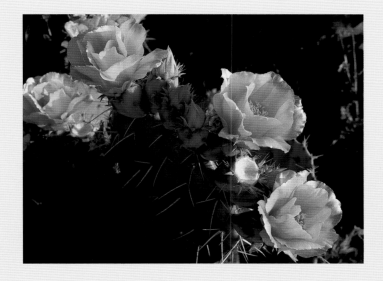

*Prickly pear cacti, Palo Alto Battlefield National Historic Site*

by hunting leases for economic revenue. Politicos and business leaders from around the world, including presidents and kings, chase quail and white-tailed deer around parcels of land as big as entire states.

The semitropical Rio Grande Valley at the southern end of the lower coast and the Brush Country behind it is a country unto itself, where Mexican immigrants mingle with snowbird retirees from the Midwest and ecotourism is spoken fluently, since the Valley ranks as the nation's premier birding destination. The Brush Country's prairies, the area's oak mottes, woodlands, and wetlands are vital to the Valley's function as the primary funnel for migratory birds in North America. Without both regions, populations of neotropical birds on the continent would crash precipitously. Without the Padre Island National Seashore, one of the longest undeveloped stretches of coastline found in the United States, endangered Kemp's ridley sea turtles would not be making one of the most spectacular recoveries of any species in the nation. Without the Laguna Madre between Padre Island and the mainland, one of four hypersaline bays found on Earth, the fisheries of Texas would be severely diminished.

And yet the Brush Country faces considerable pressure from the outside, largely from schemes to "develop" and "improve" this vast empty space. Population growth from the Valley, Corpus Christi, Laredo, and San Antonio is spilling into the countryside. Promoters want to site a private rocket-launching facility in the Brush Country fronting the lower coast. Politicians have attempted to relocate the navy's bombing range here. Large ranches struggling to remain economically sustainable are being divided and subdivided, fragmenting the land into smaller tracts and threatening the wildlife habitat within.

*Grains of sand* don't carry the same weight as Athlon chips or barrels of West Texas intermediate when it comes to gauging economic muscle, but to the convention and visitors bureaus that promote Galveston, Corpus Christi, and South Padre Island, the beach is gold—their communities' greatest natural resource, most reliable generator of revenue, and most significant employer. Small wonder, then, that each CVB claims that its city is the Big Kahuna of the Texas coast. Galveston, the oldest coastal resort in Texas, claims to attract more than 7 million visitors a year. Corpus Christi touts beach tourism as a $600 million industry. South Padre Island attracts close to 4 million visitors a year, most of them overnighters rather than daytrippers, unlike Galveston's tourists.

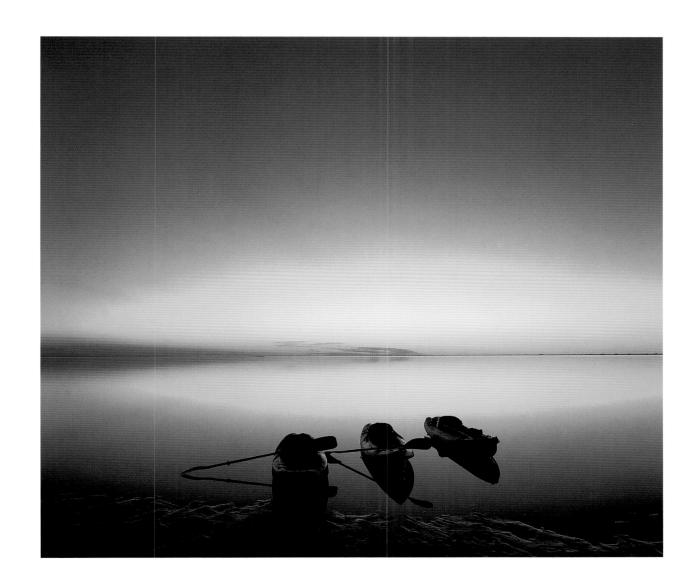

*Laguna Madre and kayaks, Padre Island National Seashore*

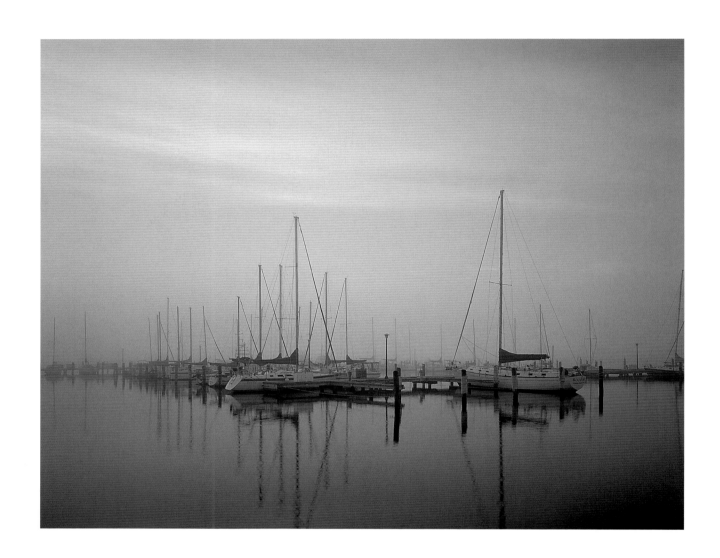

*Marina with sailboats, Corpus Christi*

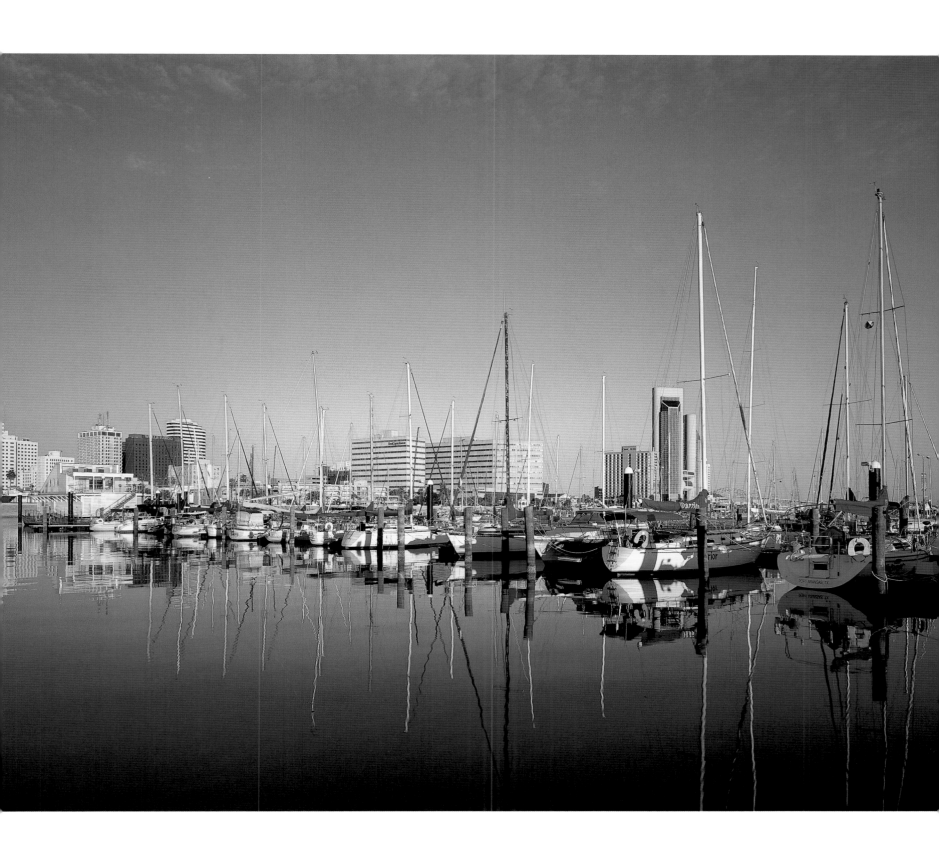

*Marina and downtown Corpus Christi*

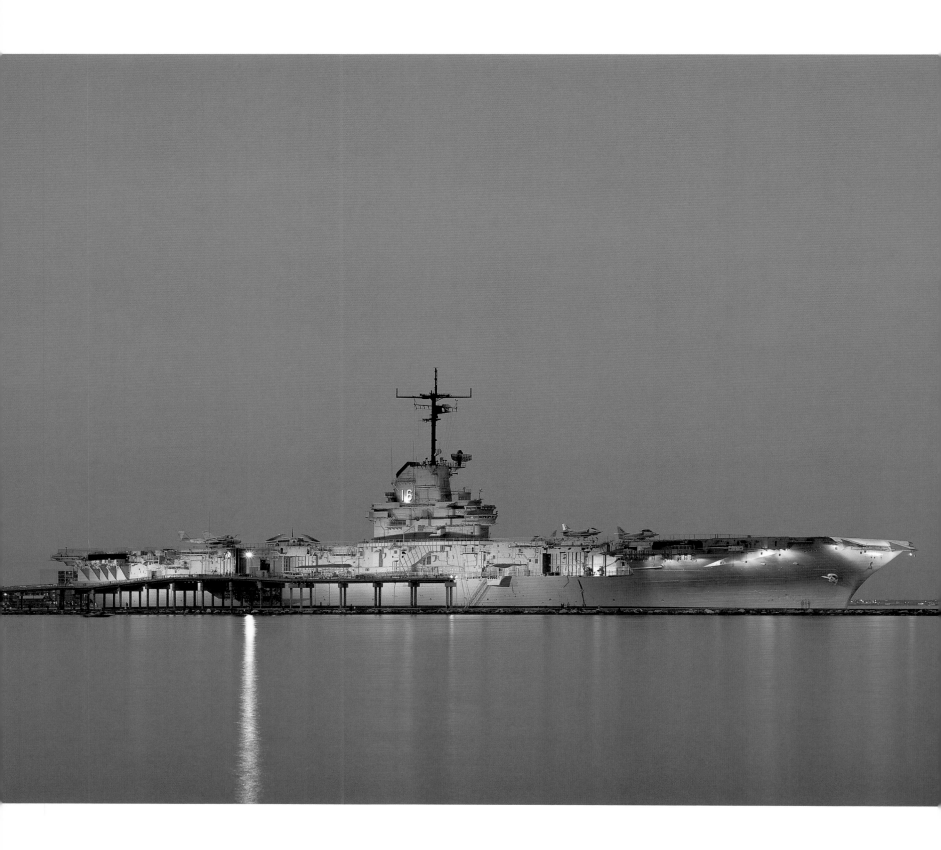

*U.S.S.* Lexington, *"the Blue Ghost," Corpus Christi*

Each destination targets a primary market—Galveston, Houston; Corpus, San Antonio; South Padre, the Rio Grande Valley. And each locale tries to sell amenities other than the beach: the Strand, Moody Gardens, and historic homes in Galveston; the Bayfront arts district, the U.S.S. *Lexington,* and the Texas State Aquarium in Corpus; and in the case of South Padre, nearby attractions such as the Laguna Atascosa Wildlife Refuge across the bay and the new Laguna Madre Nature Trail—not to mention Mexico, a thirty-minute drive from the island.

For all the added attractions, though, the sales pitch ultimately boils down to the sand, which is why being green has become a key strategy for getting green. Protecting dunes, keeping a clean beach, and maintaining a horizon free of offshore oil rigs is good for business. If only an entrepreneur could figure out how to exploit the seaweed that washes ashore for commercial use or find a use for the Portuguese man-of-war jellyfish, whose sting is one beach memory that few cherish.

*Beneath the glitz and glitter* of the high rises, upscale malls, oceanview suites, gated communities, palm-studded resorts, spring break, bungee jumps, professional sand castle builders, whaling walls, mega-size T-shirt shops, beer bongs, windsurfing, kite boarding, parasailing, jet skis, sunset bars, theme parks, and various and sundry other amusements and attractions, there's still something fragile and precious about South Padre Island. The premier beach resort of the Texas coast, separated from the northern part of Padre Island by the Port Mansfield Cut, isn't much of a landmass—low, flat, and no more than three-quarters of a mile wide along its twenty-five-mile length.

The island is a young'un in geologic time, having formed 10,000 years ago along with the other barrier islands fronting the Texas coast—Mustang, San Jose, Matagorda, Follets, Galveston, and Bolivar. South Padre is youthful in its real-time outlook too, having evolved into a major tourist destination in less than four decades.

South Padre has the warmest and clearest water and the best surf in Texas. It's the third-best beach in the United States, according to the Travel Channel cable television network, for whatever that's worth. It's a major destination for the nation's youth every March and the major resort for affluent residents in the Mexican states of Tamaulipas and Nuevo León as well. Half of the island's condo owners are from Monterrey.

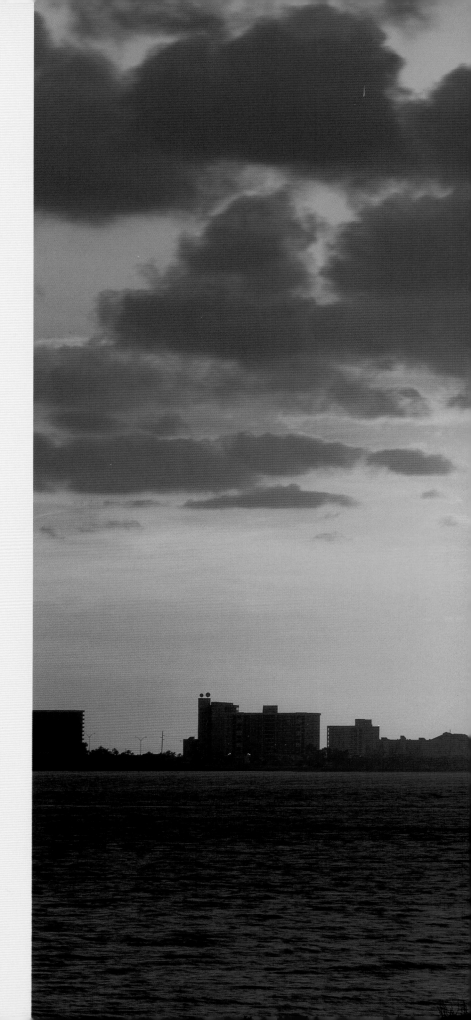

On a Saturday in late May while most of the weekend visitors are grumbling about the lack of sunshine, a huge array of other travelers occupy the tree limbs of backyard habitats that dot the town. Intermittent rains and gusty winds have caused a fallout. Birds flying across the Gulf from the Yucatán on their spring migration north are dropping out of the sky at landfall, providing a feast of binocular viewing.

Many of the tree limbs in these mini-forests, part of the South Padre Island Migratory Sanctuary, are spiked with oranges and grapefruits to replenish the tired arrivals, who repay the favor by flashing a riot of tropical colors for the onlookers. Hummingbirds buzz to and fro, wherever a bloom shows color. Each radiant blur of yellow, green, and blue has a name: Northern water-thrush. Rose-breasted grosbeak. Indigo bunting. Tennessee warbler. Magnolia warbler. Hooded warbler.

From the wetlands boardwalk at the convention center, another major birding spot at the north end of town, a Swainson's hawk is being photographed through a telephoto lens less than twenty feet from the building.

At the southern tip of the island, a small houseboat putters by Dolphin Cove

*South Padre Island hotels*
*across Laguna Madre*

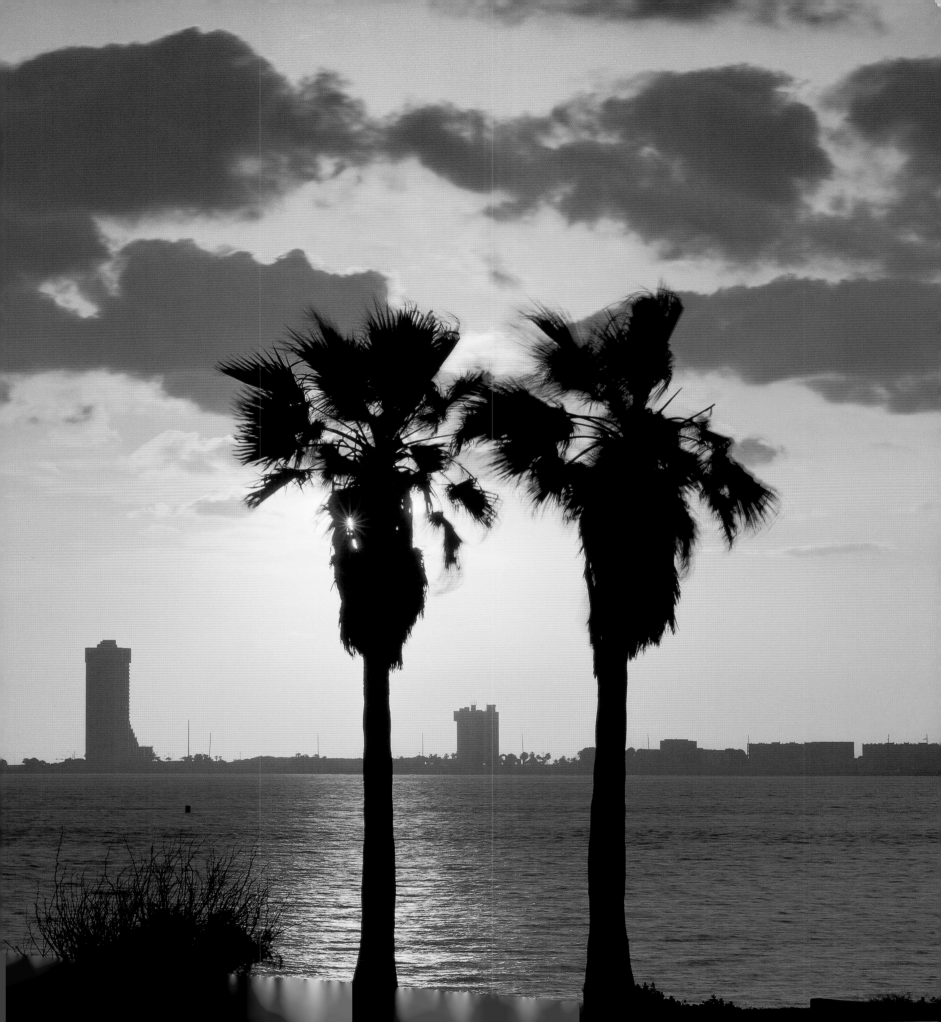

*South Padre Island beach*

in Brazos Santiago Pass and the Laguna Madre, looking for Atlantic bottlenose dolphins while white lightning flashes against a black sky far in the distance, the portent of a tropical thunderstorm to come.

A larger sightseeing boat veers close enough that the sound of Jimmy Buffett warbling on the sound system cuts through the squawk of the gulls, prompting the smaller boat to change course and head toward South Bay. A net is dipped into the water, yielding a clump of floating sargassum teeming with tiny shrimp, a nudibranch (a tide pool invertebrate also known as a seaclown for its bright spots), and a little pipefish.

The boat passes a noble osprey, the sea hawk, perched on a piling marking the channel, close enough that the bird takes flight, revealing a fish squirming in its claws. Near South Bay, on an Audubon nesting island, a roseate spoonbill shows pink on the shoreline. Pinheads and widgeons float contentedly on the water.

The sheet of rain finally reaches the boat, along with sharp gusts, rumbling thunder, and bolts of lightning. The vessel heads for port.

The Town of South Padre extends for only a few miles on the southern tip of the island, and the paved road north stops after eight miles. Much of the rest of the land north has been purchased by the Nature Conservancy in order to ensure that it will be left in its wild state. And yet the town booms and blossoms and grows and continues attracting a wide range of folks from all over the world. A few of them stay.

*Morning is the best time* to be on the beach. Though the blazing summer sun has risen out of the Gulf, it is too fresh, too young, too early to sear the skin.

Early risers dot the shoreline. Some jog. Most walk or stroll. Shellers inspect the wet sand for treasures brought ashore by the tides, while sandpipers pick at the sargassum washed up and into the tiny holes made by coquina clams. An elderly Latina chatters into a cell phone as she walks by, but the breeze blots out her words. An older couple with identical paunches, tank tops, and metal detectors begin their search for booty. Another couple hold hands as they walk, oblivious to everything but each other. Solo walkers embrace the solitude and the sound track of crashing waves. Gulls scamper to the water's edge and retreat as the waves advance. Pelicans patrol the waters from above. Fishermen stand knee deep in water, casting into waves while bodysurfers try to jump into them. Beyond the third sandbar, two surfers test the bigger breakers.

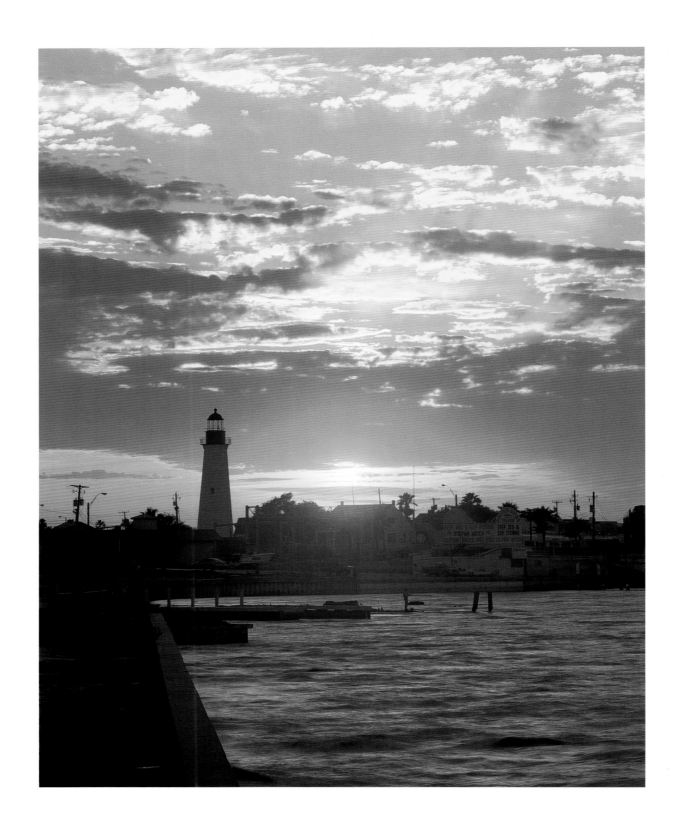

*Port Isabel Lighthouse State Historic Park*

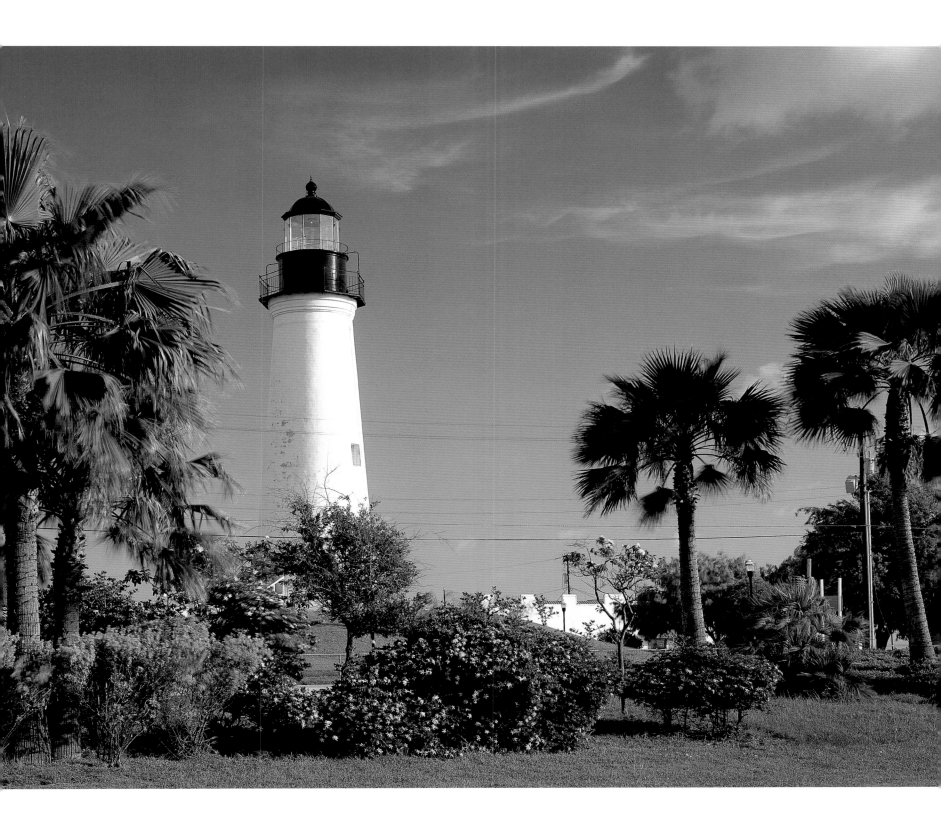

*Port Isabel Lighthouse State Historic Park*

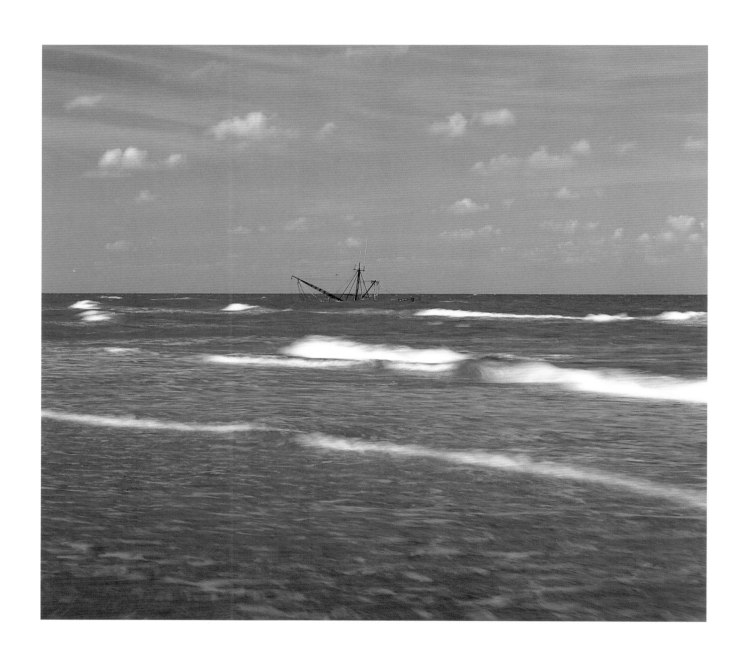

*Surf with shipwreck, South Padre Island*

*Shrimp boats, Port Isabel*

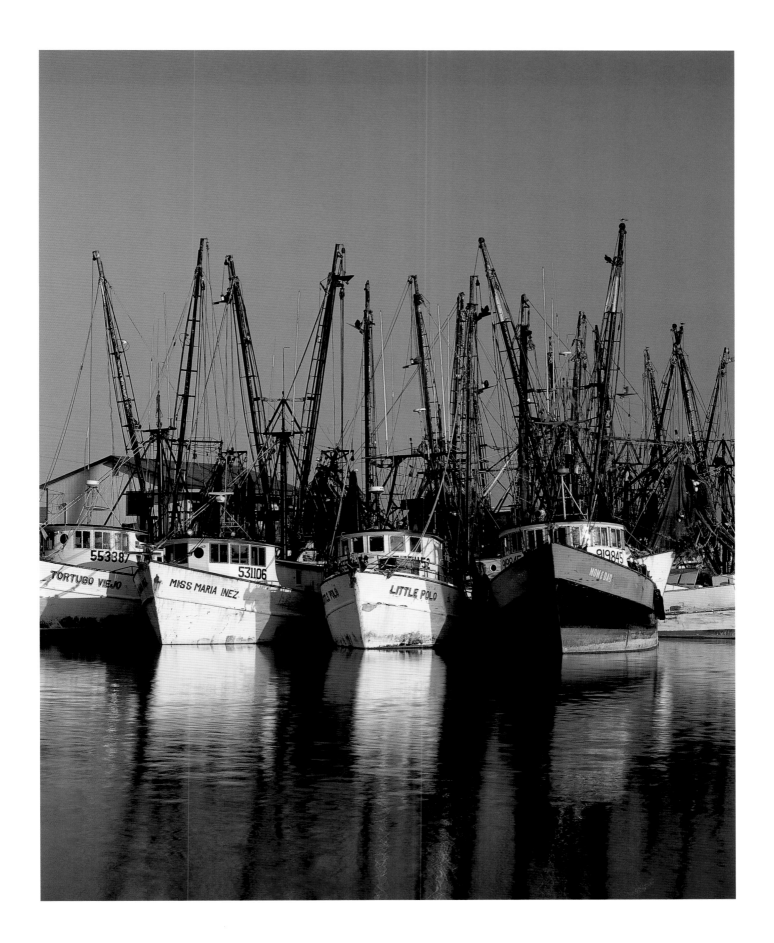

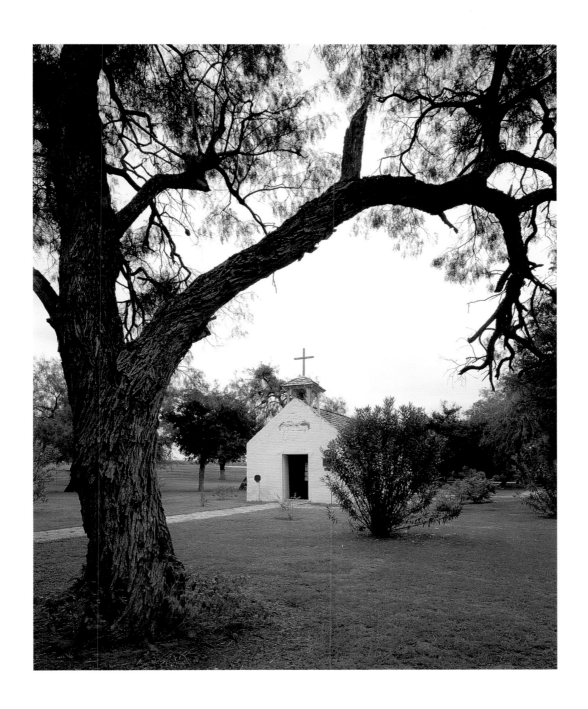

*La Lomita Chapel, Mission*

*Audubon Sabal Palm Refuge, Brownsville*

*Rain and thick clouds* erase the lines. Land, air, water are one. The far-flung flats are flatter than flat, tamped down by the soaking showers. Mesquite, prickly pear, tall yucca define the green cap covering the dunes.

*Boca Chica,* the last stretch of the Texas coast, is not the kind of place to get stranded in. Relentlessly hot and humid most of the year, buggy, thorny, and gnarly, it is devoid of much human evidence, save for a few relics of failed developments, markers identifying boundaries of the Lower Rio Grande Valley National Wildlife Refuge, and the odd truck bearing fishermen on the beach.

There are no services, no shops. The nearby Border Patrol checkpoint is a small trailer.

The solitude is splendid. The last spit of land on the coastline of Texas has been ceded to the wild world, with exceptions made for the Border Patrol, the Drug Enforcement Administration, the fishermen, and the odd would-be immigrant making his or her way up from Mexico.

Human occupants have never fared well on Boca Chica. Camp Belknap was established on the first high ground inland in 1846 as the base camp for eight thousand soldiers fighting the Mexican War. Suffering from exposure to the elements, unsanitary living conditions, biting insects, thorny plants, and one to two funerals a day, it lasted less than a year. The Battle of Palmetto Ranch, the last engagement of the Civil War, was fought a few miles inland on May 12 and 13, 1865, thirty-four days after Robert E. Lee surrendered at Appomattox.

A little more than one hundred years later, Kopernik Shores was established nearby. Its promoters directed their sales pitch to Polish immigrants living in the Chicago area, promising a tropical paradise while neglecting to tell them that the two-block subdivision lacked a water system.

The subdivision was renamed Boca Chica Village but remains pretty much a ghost town. It's easy to tell which few homes are occupied—they're the ones with the 1,500-gallon plastic rain barrels in the yard.

The beach at Boca Chica is completely natural, meaning there's plenty of trash washed ashore along with the sargassum. At low tide and during dry periods, the beach gets plenty of traffic, mainly pickups and campers carrying fishermen from Brownsville and elsewhere in the Valley. From the end of the asphalt, it's a couple

*Goat-foot morning glories, Boca Chica Beach*

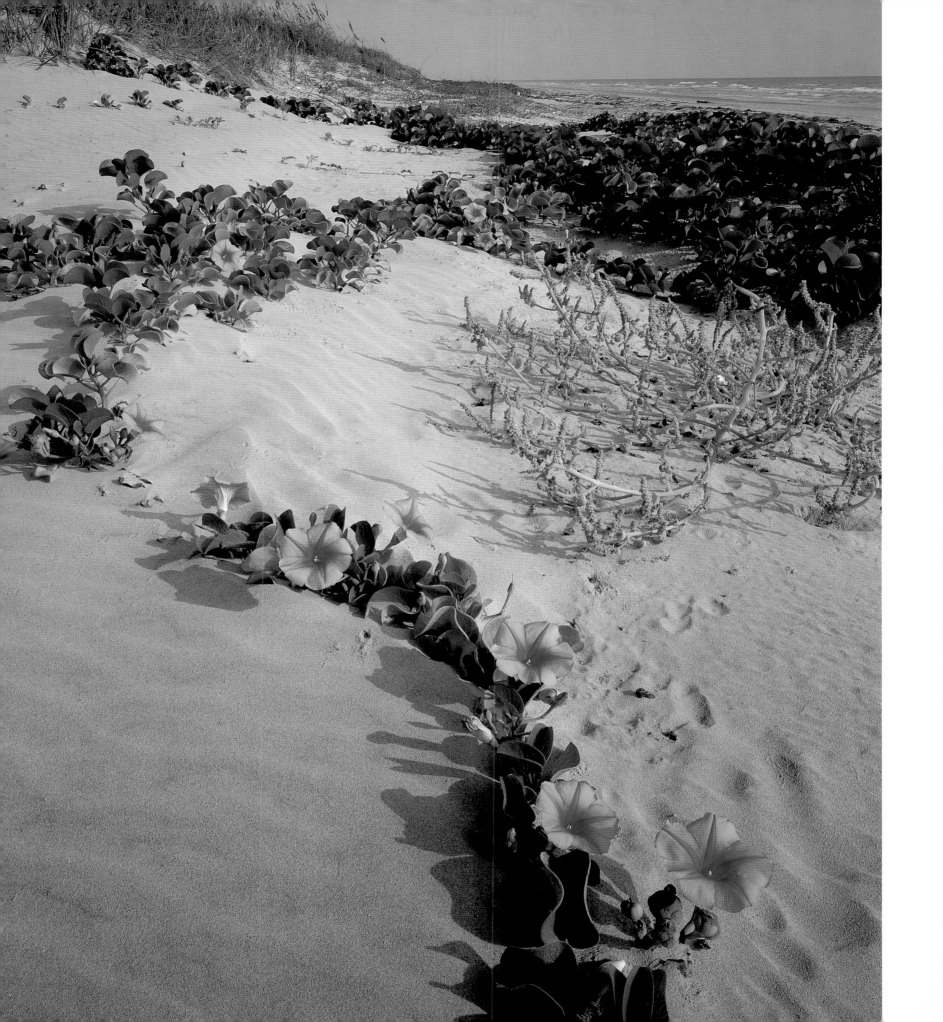

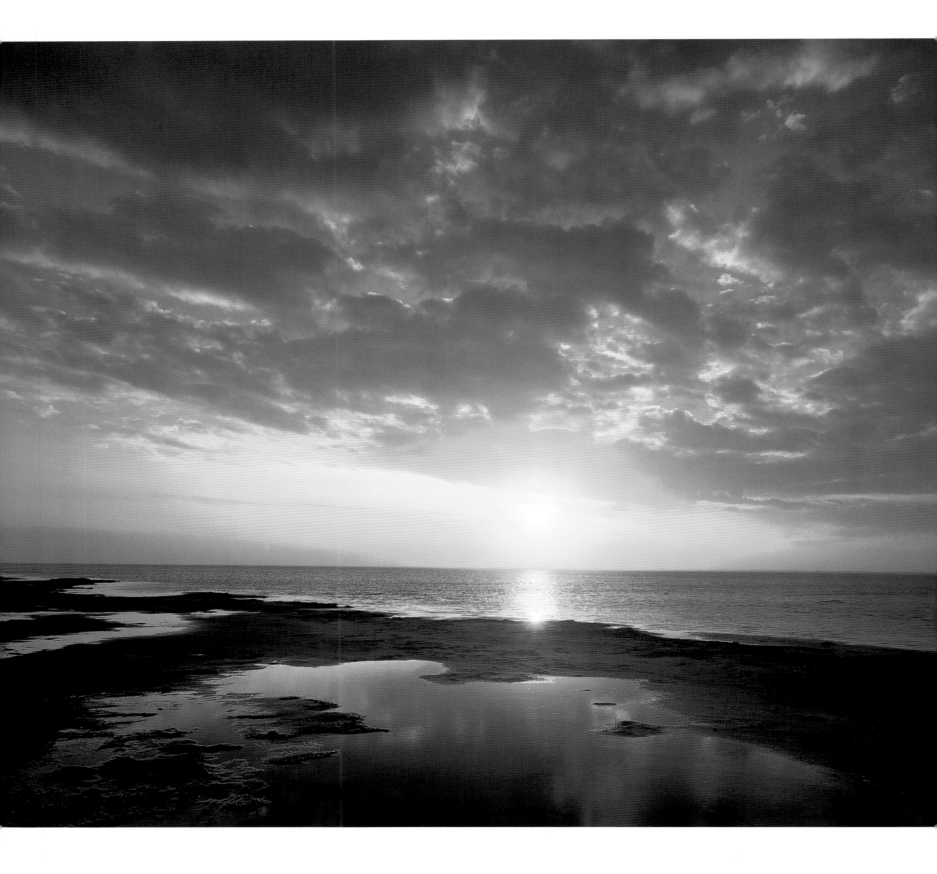

of miles to the mouth of the Rio Grande, a vague, ill-defined demarcation among the dunes. The river has been rendered less grand over the past century and a half. Demand for water upstream for agriculture and for cities has increased to the point that in the late 1990s the Rio Grande no longer reached the Gulf of Mexico on its two-thousand-mile journey from the Rockies. Even during wet periods, when it does run to the Gulf, the river is no more than a hundred yards wide, a vague channel between swirls of sand. In drier times, the great divide between the First World and the Third World, the United States and Mexico, and Texas and Tamaulipas becomes merely a land bridge.

That explains the frequent presence of officers from the Border Patrol and the Drug Enforcement Administration on this side and the Mexican police on the other. They acknowledge the legacy of Baghdad across the way, the port from which Confederate states shipped smuggled cotton overseas during the Civil War, and of the pirates, arms merchants, dope smugglers, and hustlers who have taken advantage of the invisible line since then. A common tale is told of the coyote smuggler who gets paid hundreds and thousands of dollars to move humans across the border, putting naive Mexicanos on boats, pointing to the high rises of South Padre, seven miles distant, and telling them it's Houston.

Next-to-last impression: The end of the Texas coast somehow deserves more drama than Boca Chica is willing to give. The lighthouse on the Mexican side is all function over form, lacking any character whatsoever.

Last impression, after soaking up the emptiness alongside the gulls, the pipers, the pelicans, and even the men-of-war, their purple-and-blue-tinged translucent sails shimmering in the wind, and the inkfish, their gooey blobs heaving and contracting on the wet sand, drawing life: Visual fireworks are unnecessary. This is how the Texas coast should end.

The coast goes on, of course, deep into Mexico, to warmer water, beaches that are wilder and less populated, down past Tampico to Veracruz, where Cortés first set foot on the mainland of the Americas, around the big Gulf tub to Campeche and the Yucatán, where the Gulf and the Caribbean embrace. But the mouth of the Rio Grande marks the completion of the Texas crescent, the endpoint of the line that is to many of us the coast of dreams.

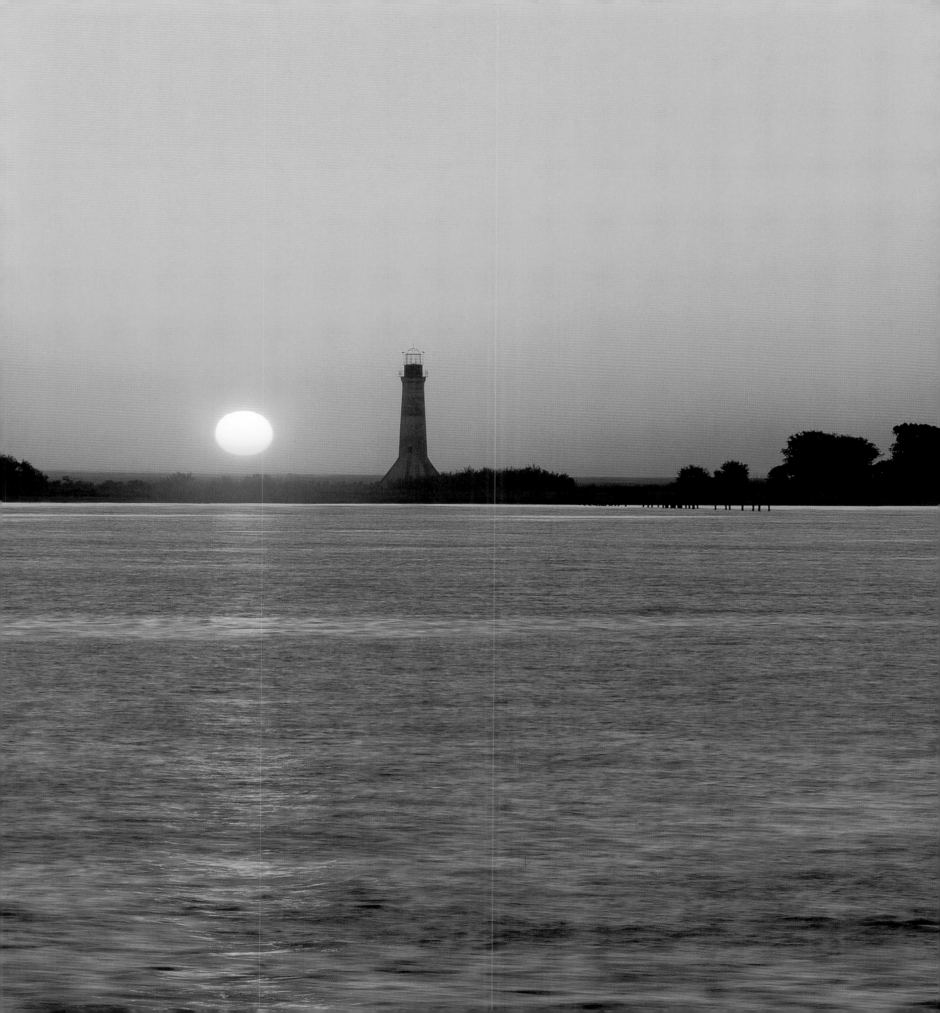

*Live oaks, Brazos Bend State Park*
PRECEDING PAGES: *Sabine Pass Lighthouse*

*Horseshoe Lake, Brazoria County*

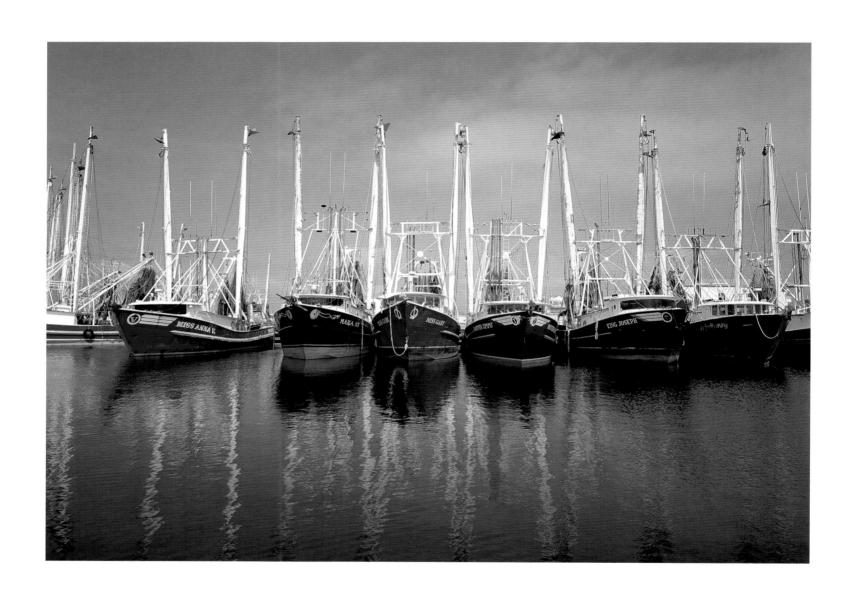

*Shrimp boats in the harbor, Palacios*

ACKNOWLEDGMENTS

*T*hanks go to Charles Butt for helping produce this book and for allowing me access to his restored lighthouse, to Rick and Cameron Pratt for helping with the lighthouse photos, to Dale and Delilah Linenberger for their hospitality and help with photos in the Corpus Christi area, to James and Patsie Caperton for their endless hospitality when I was on the upper coast, and to the staff of Matagorda Island State Park for assisting me in obtaining photos on the island.

—L.P.

*S*pecial thanks to the following people, whose knowledge, insight, and wisdom provided the paint for the word pictures accompanying these photographs.

Erin Albert, Carole Allen, Ray Allen, Tony Amos, Michael Berryhill, Boomerang Billy, Wesley Blevins, Fred Bryant, Ernie Buttler, Scarlet and Captain George Colley, Richard Dobson, Captain Gary Einkauf, Johnny French, James Fulbright, Ronnie Gallagher, Billy Hamlin, Bill Harvey, Jeff Henry, Mickey Herskowitz, Josh Mackey, Danny Magourik, Captain Sally Ann Moffett, Paul Montagna, Brien Nicolau, Mike and Earl Osten, Rick Pratt, Butch Ryal, Dr. Donna Shaver, Tom Stehn, Douglas Tinker, Dr. Jim Tolan, Dr. Wes Tunnell, Lucinda (Sandy Feet) Wierenga, Diane Wilson, Paul Wimberly.

—J.N.P.

*Texas Coast*

was designed and composed by Teresa W. Wingfield
in Adobe InDesign on a Macintosh,
12.5 on 18 Bembo, display face Poetica
and
printed and bound by
C&C Offset Printing Co., Ltd., Hong Kong, China

140 gsm Chinese Gold East Matte

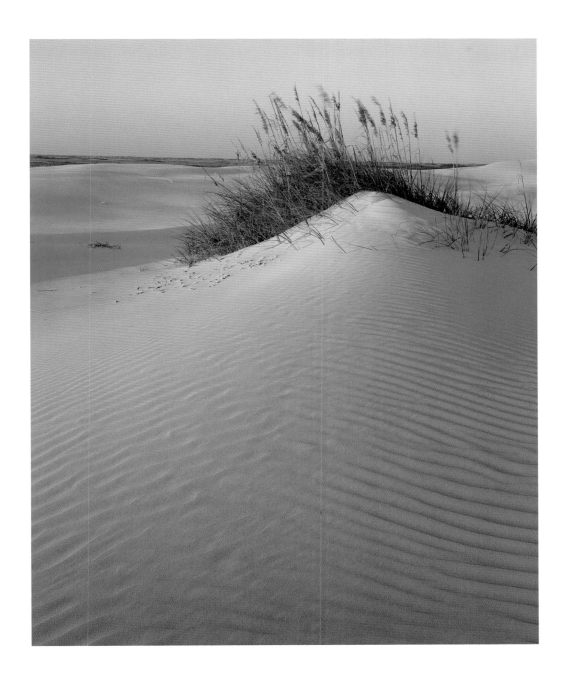

*Padre Island National Seashore*